Contents

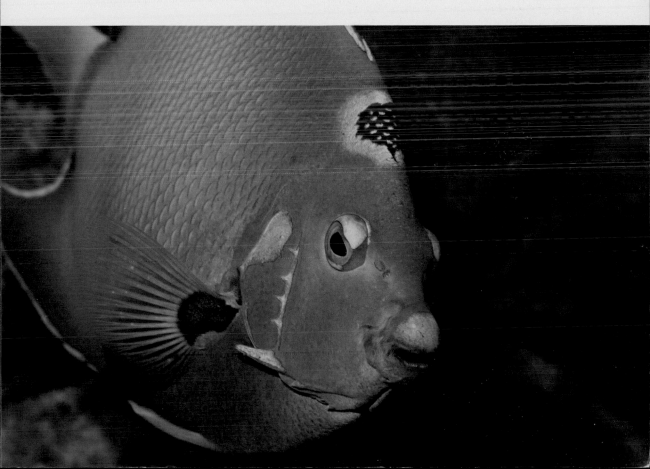

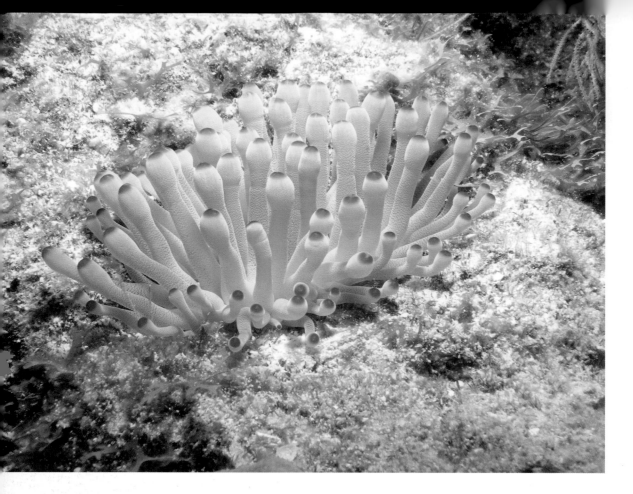

SPECIAL THANKS AND DEDICATION

I traveled far and wide to find the best of the best to engage with to bring this work forward. Many thanks go out to my contributors (see page 124), but I would also like to thank A & A Brinkley of Oklahoma, Aja Vickers of Oregon, Jerry Ryan from Texas, Kelly Rabe of California, Rick Voight of Vivid-Pix in Georgia, Scott Stackel in Nevada, Steve Minor from the UK, and Wendy Lamont from South Dakota. Thank you too, to my publisher, Craig Alesse, for his patience and understanding and to my editor, Barbara Lynch-Johnt, for her guidance and perseverance.

This work is dedicated to my friends both in and out of the business who have supported me in all ways and through the years and the times we shared together. I reviewed countless images while compiling this work and know that as many memories of you came to mind. Thank you.

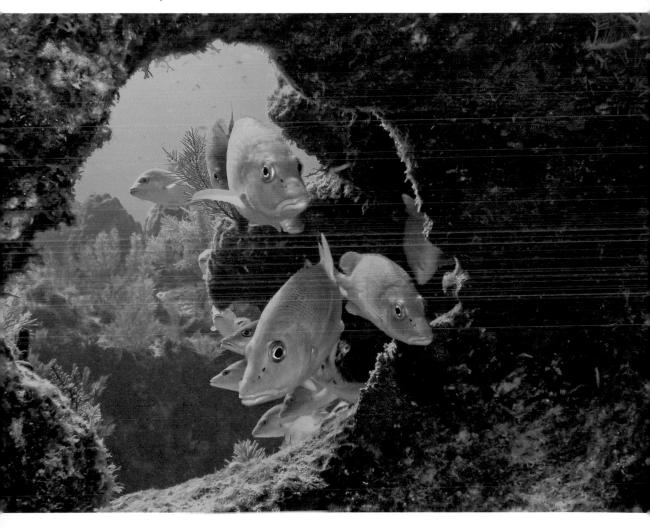

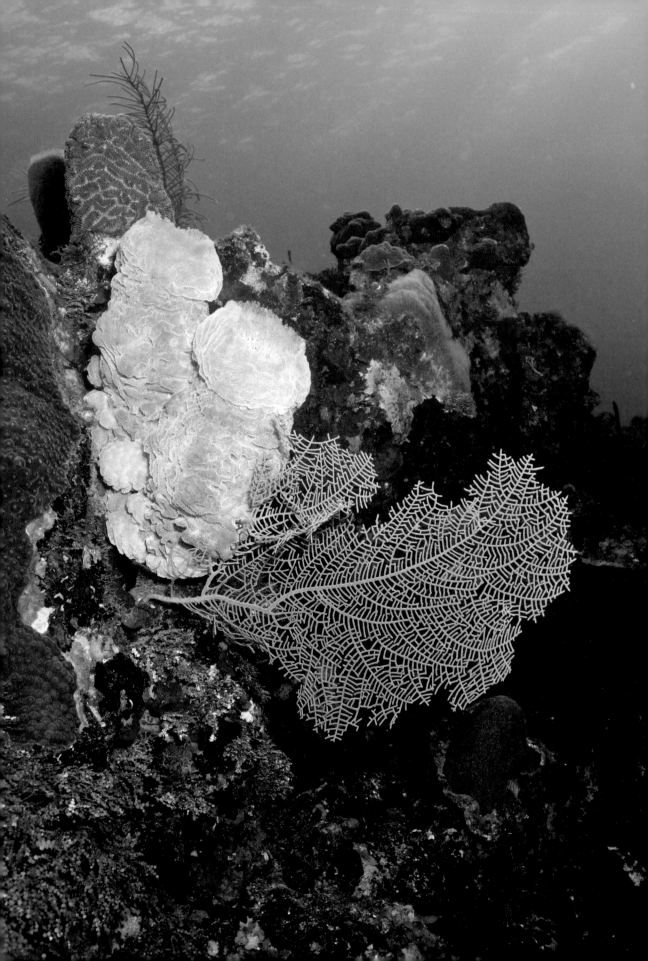

Introduction

This guide is a learning tool. It is organized by the type of camera, lenses, and other equipment used to take the photographs illustrated here. I've also organized this book in the same sequence that most of us progress through our underwater photography, beginning with point & shoot cameras, a housing, and a strobe—and moving to a housed dSLR camera. From there, we add lenses and other accessories to our inventory.

These pages show the types of equipment we use and the images that can be made using underwater photography gear. It is written in lay terms, save the taxonomical naming of most of the marine organisms, so that a beginner can easily understand. I avoid highly technical discussions and diagrams, graphs, and charts in this work.

This is my third "how to" book on underwater photography. The first was *The Beginner's Guide to Underwater Digital Photography* and the second was *Advanced Underwater Photography*. The second book more or less took off where the first book left off. This was very much analogous to taking the Advanced Open Water Diver course sometime after the completion of the Open Water Diver Course.

This pictorial guide follows suit. This work was compiled with the assumption that the reader is getting started with or has been doing underwater photography for a short while and is on the left and upward side of a Bell learning curve.

Beginning on page 16, the content is mostly underwater photos with accompanying text about each image. The text gives the recipe for the image. The ingredients include, whenever possible: where the photo was taken, the equipment used, the exposure data, the distance to the subject, and what the subject is (in many instances both its lay name and taxonomical name are given). The text often includes tips, tricks, techniques, and suggestions for taking underwater photographs in general, as well. This combination of photo and prose aims at arming the reader with information that they can use to repeat the performance.

This work takes its readers on a couple of short dives into areas that I have not seen previously written about. The first is about the challenges inherent in creating underwater photography in fresh or freshwater-like environments.

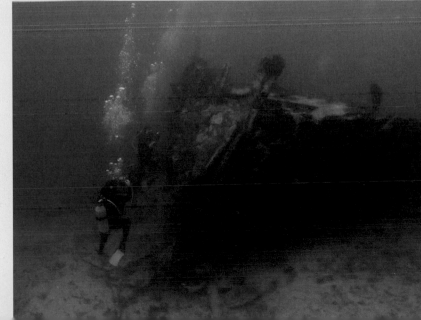

The second of these is a brief introduction to an entirely new (within the past two years or so) type of underwater photography. This is doing underwater photography using a smartphone camera in an underwater housing. I find this new approach quite exciting and intriguing.

It does not take a long time to learn to SCUBA dive and, after that, it does not take long to acquire a liking for underwater photography nor long to acquire a basic but capable underwater photography camera system. The time it takes to grow as a diver and an underwater photographer varies with passion and experience. Sooner or later, we reach a plateau in our underwater photography. So I have included a portion of this work to help photographers move beyond

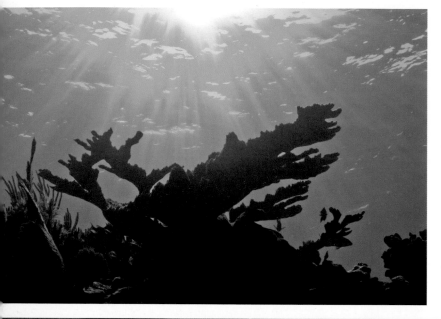

Left—Silhouettes fall in the realm of underwater photographic art. This image of Elkhorn Coral *(Acropora palmata)* was made with a housed Canon dSLR at a focal length of 18mm with the lens behind a large dome port. No strobe was used. The exposure was f/10, $1/160$ second, and ISO 100. The subject distance was 3 feet. **Below**—A Christmas Tree Worm *(Spirobanchus giganteus)* is a subject best suited to shoot using a macro lens or a camera's macro setting due to their small size. This specimen is less than 2 inches in height.

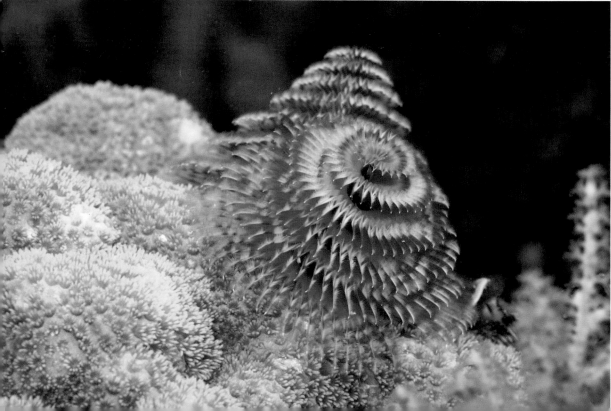

that point in time. There is a section on how some of the artful and popular underwater images are made.

There are times when our photos do not turn out exactly the way we thought they did at the time we took them. To help with this, this book includes a chapter on editing photos using a modest workflow that also speaks to organizing photos for later use.

I've used contributors' imagery and comments in this work. This is because I may not have used the equipment (smartphone underwater photography), do not have a particular image I wanted to present (a Dragon Moray), the contributor had a nicer image than I to use for the example (a Splendid Cozumel Toadfish), I have not dove the environment where the subjects were found (Guadalupe Island), or because I have lost images I once had over the years (freshwater diving). The contributors are acknowledged throughout the work and at the end of the book, thanked.

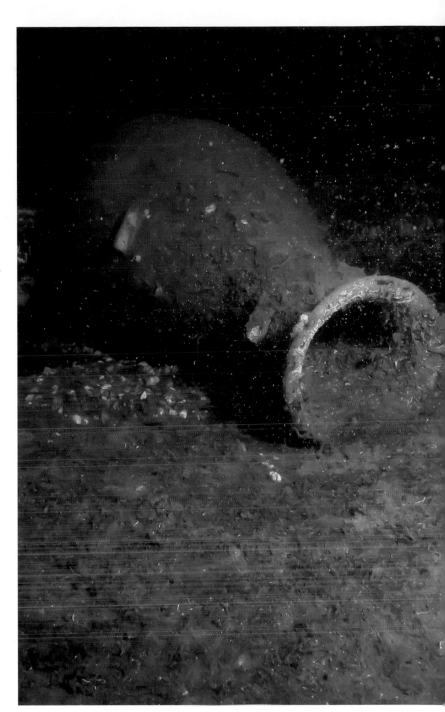

Many underwater photos are taken each year in environments other than the pristine, clear-blue waters of the coral reef environment. This Amphora image was taken in the Emerald Lagoon, an inland body of green water in Key Largo, FL. These waters tend to be turbid, with limited visibility, presenting the challenge of reducing backscatter.

Equipment

The advancements during the past couple of decades in the technology, design innovations, and amount of equipment that we can choose from and use in our underwater digital photography is astounding. In some cases, the advancements have exceeded the film camera underwater systems of the past and certainly the digital camera underwater systems of the past decade—particularly with respect to autofocus (both film and digital) and shutter and digital lag (early digital cameras), which are virtually a thing of the past. Similarly, many of today's strobes offer internal modeling/focusing lights and, more importantly, improved functionality, reliability, and accuracy of their TTL features. Furthermore, housings are made for increasing numbers of brands and models of all types of cameras.

An underwater camera system can range in cost from around $1000 to around $30,000. This chapter details most of the basic equipment that you would spend that money on.

Spending more money on equipment will not make you a better underwater photographer. I upgrade my equipment when the gear I have is not able to take the type of photograph I want to take or to make my picture-taking easier. For example, it is easier for me to compose using the viewfinder on a digital single-reflex camera (dSLR) than to frame my shots using the LCD of a point & shoot (PnS) camera, so I upgraded to a dSLR. I also upgrade my equipment when a significant technological advancement to that piece of equipment has been achieved (e.g., an increase in the camera's dynamic range or a faster recycle time of the strobe).

This chapter features images and descriptions of equipment used to take the photos featured in this book. Having this equipment or equivalent equipment will enable you to take similar images.

CAMERAS

We still use the same types of digital cameras in our underwater photography as we did even a few short years ago and from the beginning of the digital paradigm. They are the basic PnS camera, the full-featured PnS camera, and the dSLR camera. Of course, there is a new entry to the market—the cameras in our smartphones. A relative newcomer to the scene is another type of PnS camera, the mirrorless camera. Mirrorless cameras have interchangeable lenses like dSLRs but do not have a mirror/prism viewfinder like dSLRs. Advantages of using such a camera include the small size and the fact that they accept interchangeable lenses.

The components of an underwater camera system have not changed. They are: the camera, a waterproof camera housing made of polycarbonate or marine-grade aluminum, a lens port (either flat or dome) mounted to the front opening of the housing, port extenders of varying lengths depending upon the lens used, and a camera tray, which

mounts to the housing's underside and holds accessories such as handles and the components of the strobe or strobes. (Some camera housings do not require a camera tray.) Handles mount to the tray or housing. Ball-head adaptors are used, which mount to the tray, handle, or housing. Adjustable clamps are used and attached to a ball-head adaptor on one end of the clamp and to a strobe arm or another adaptor on the other end. A second clamp fixes to the strobe arm and to (in some cases another strobe arm and another clamp to that arm) a strobe head adaptor, which attaches to the strobe. These components physically connect the strobe to the camera housing.

A strobe arm or arms (and clamps) are used to position the strobe in order to direct the light where it is needed. These accessories allow you to move the strobe away from the camera's lens, which will help prevent backscatter, and to bring the strobe closer to or farther from the subject to affect exposure.

We connect the camera to the strobe so that the strobe fires as the shutter opens. This connection is made via a fiber-optic cable or an electrical sync cord. The former is more common; the latter is used primarily when the camera has no built-in flash.

PORTS

We use two types of ports in underwater photography: flat ports and dome ports. These are fitted either with or without a port extender depending on the lens used and to the front opening (lens orifice) of dSLR housings to accommodate the lens.

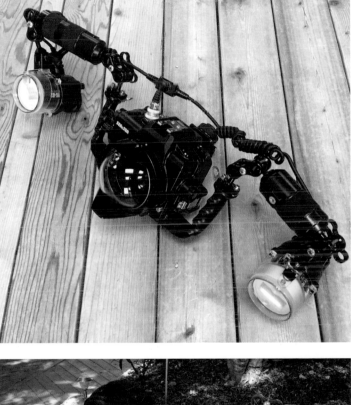

Top—This is a complete underwater camera system, showing a housed dSLR, small dome port, two handles, two strobes and their adaptors, buoyant strobe arms, clamps, and electrical sync cords. Photo courtesy of Steve Philbrook. Bottom—Pictured are two dSLR systems— one outfitted with a flat port and the other with a large dome port. Both strobes are fitted with diffusers.

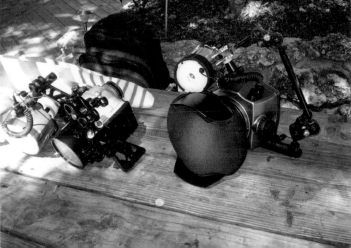

Flat ports are cylindrical and usually made of metal. They are open on the housing end and glass-covered on the end that the lens "sees" through. Flat ports are primarily used in macro photography, though they will work with some wide-angle lenses that are not very wide in angle of view. The housings for PnS cameras have built-in ports, which are flat, though not necessarily round. Flat ports are subject to refraction, like our dive masks. They reduce the lens's angle of view and make the subject appear closer.

Dome ports are a segment of a sphere, concave in shape and made of optical-quality glass or clear acrylic. They are used with wide-angle lenses and preserve the lens's angle of view. Dome ports are needed when using wider-angle lenses to prevent vignetting. Depending upon the physical length of the lens and the focal length of the lens, a port extender may be needed. Port manu-

facturers have lens/port charts to determine the type of port recommended and length of extender needed, if any. The extender is an open-ended metal cylinder with fittings on each end. It is mounted between the housing and the port, flat or dome.

In this book, I refer to small dome ports and large dome ports. Small domes are up to 6 inches in diameter and include mini domes. Large domes are greater than 6 inches in diameter. A super dome is about 12 inches in diameter. The domes I use are just under 5 inches and just over 6 inches in diameter. Dome diameters are also given in millimeters.

The full-featured PnS underwater camera system gives us all the advantages of a basic PnS, plus full manual control over our exposure settings. These cameras have a variable focal length zoom lens and most have a macro setting (which decreases the minimum focusing distance). Both the basic

The Sea Life DC 1000 (photo courtesy of Hector Sequin, Jr.) is a basic PnS camera. A camera of this type is fully automatic and does not afford its user much, if any, manual control over exposure. They can be used with or without an external strobe and other accessory components and usually have a variable zoom lens. Most have a macro setting and some offer an underwater setting. The photographer can set the ISO and white balance manually (though these cameras offer white balance presents, as well). Basic PnS cameras have a built-in flash. When used with an external strobe, the camera's internal flash triggers the external strobe. The modern PnS camera has an impressive number of megapixels (this model offers 10MP), a nearly immeasurable amount of digital and shutter lag, and is very capable with respect to image quality. Its compact size and light weight make it easy to dive and travel with, and it is generally quite affordable. Hector mainly uses his GoPro and shoots videos when working his dives but brings his PnS along to grab shots that are better made with a still camera.

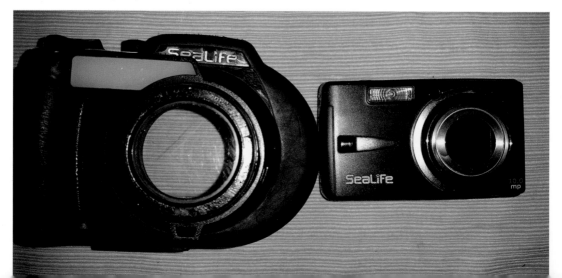

Top—A full-featured PnS camera system. This is an Olympus XZ-1, a full-featured PnS camera, in a Nauticam housing. This image shows the components of an underwater camera system: housing, port, tray, handles, two strobes, fiber-optic cables, adaptors, clamps, and (buoyant) strobe arms. Photo courtesy of John Shaheen. Center—This book features sections on using two macro lenses: the 60mm and the 100mm. This image shows a dSLR with a 100mm macro lens. The lens has a long barrel, and it is necessary to use a port extender between the housing and the flat port, as seen here. A single strobe is mounted. When doing macro photography, it is good to position the strobe as shown, centered over the lens and positioned forward enough so the port does not cause the strobe to cast a shadow into the frame. Bottom—The new wave in under-

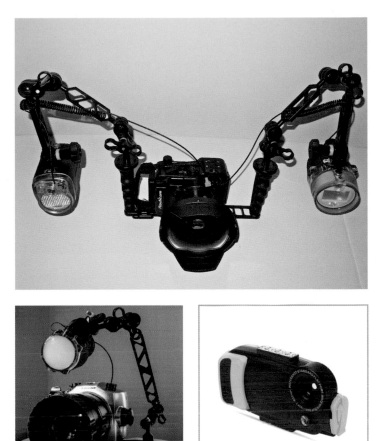

water photography is using a smartphone in a housing to take underwater photographs. This is a photo of the Watershot Pro Line housing for the iPhone. An array of accessories, including a wide-angle dome for wide-angle photography, can also be purchased. A housed smartphone is an affordable, easy-to-pack backup for an underwater photographer's primary system.

and full-featured PnS can also accomodate wet-lenses of different angles of view, from macro to ultra-wide-angle, enabling users to photograph subjects of various sizes during the dive. This is an advantage over dSLRs, which require us to commit to using the lens mounted before the dive.

STROBES

External strobes are used to compensate for ambient light that is absorbed by the water column due to depth or distance. There are a few key considerations when selecting a strobe. In no particular order, they are: power output, recycle time, angle of coverage, how they are powered, how many flashes it fires before the power is consumed, the light quality (measured in Kelvin units), TTL capability, size, and price.

The guide number (GN) is a rating of the power output capability of the strobe. The higher the GN, the more powerful the strobe

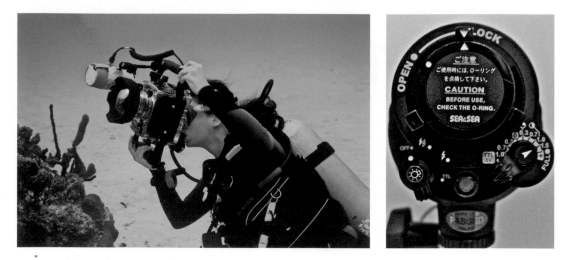

Left—Camera with strobe and dome port. Right—Strobe controls. Photo courtesy of John Shaheen.

is. GNs range from 20 to 30 or higher. A higher guide number allows you to shoot using a smaller aperture, which provides greater depth of field.

Recycle time is how long, in seconds, it takes for the strobe's capacitor to recharge between shots. Obviously, the shorter the recycle time, the better. A 1.5-second recycle time is considered very good, but a recycle time of a few seconds is not so good.

Angle of coverage is important. It is desirable to have the angle of coverage of the strobe match or exceed the angle of view of the lens used. If the strobe's angle of coverage is less, the image will be vignetted.

Throughout this book, you will read about diffusers and diffused strobes. Diffusers are thin, plastic opaque discs that fit over the face of the strobe. They serve two purposes: One is to soften the light from the strobe. The second and main purpose is to increase, by diffusing, the strobe's angle of coverage, by approximately 10 degrees. The trade-off is the loss of approximately 1 f/stop worth of strobe output.

The quality of a strobe's light is measured in Kelvin units. Sunlight is roughly 5500 Kelvin. Most strobes produce light that measures 4800 to 5500 Kelvin.

TTL (through-the-lens) technology allows the camera and strobe to communicate so that the strobe outputs just the right amount of light to create a correct exposure. If your strobe/camera system has TTL, the strobe will emit a full-power flash or less.

I use "travel strobes," which are smaller in size and usually accept rechargeable AA batteries rather than proprietary battery packs. My batteries will power my strobes for 200 shots before the recycle time becomes unbearably long. Travel strobes are usually more affordable than traditional strobes. The trade-off is fewer shots per charge and a lower power output.

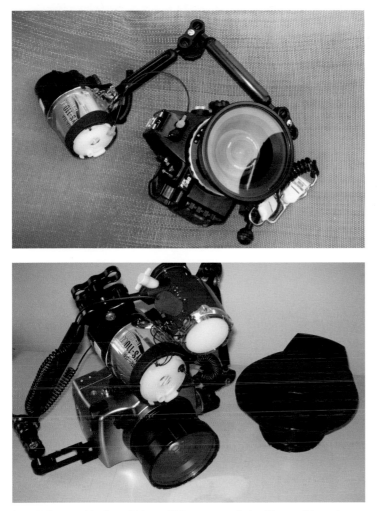

Top left—This is a student's "one sun, one strobe" dSLR system with a dome port mounted for either using a mid-range zoom lens or ultra-wide-angle lens. This housing and strobe is made by Sea & Sea and is for a Nikon dSLR. Bottom left—Pictured here is my system, set up with two strobes. I have the flat port for macro photography mounted and the large dome port sitting to the side. Right—This photo shows the use of a single 8-inch strobe arm and its ease of management. Strobe arms come in 3, 5, 8, 12, 16, and 24-inch lengths. Using arms and clamps enables us to position light where we want it.

WHAT'S NEXT?

Now that we've covered the equipment used to take great underwater images, it's time to move on to the heart of the matter—the subjects and images themselves. For the next several chapters, the photographs will be the primary focus—the star attraction. In order to best show the images, instructional text pertaining to underwater photography will be presented in caption format. We'll move through discussions on using specific camera formats and lenses of a particular type to investigate the images that can be made with that gear. With that accomplished, we will discuss postproduction work. That chapter will be presented in a body-text-and-image format, as this chapter is. Most photographers don't want to see extra-large screen shots, so those images will be shown in a more restrained size.

Ready? Set? Let's dive.

POINT & SHOOT CAMERAS

Most of us use a point & shoot (PnS) digital camera when we begin our descent into the world of underwater photography. It is very affordable compared to buying and housing a dSLR; it is also very versatile in the range of subjects it can be used to photograph. The equipment and accessories available now were not available in the early days of underwater digital photography. We jerry-rigged many PnS cameras with strobes and fixtures and other mechanics to make the best use of our equipment. Manufacturers later caught up and met our needs.

PnS cameras come in two flavors: fully automatic and full-featured. Fully automatic cameras determine the exposure and set the aperture and shutter speed. At best, we can pick the ISO (I generally set that to 100). Full-featured PnS cameras allow users to manually control all the exposure settings. Both flavors of PnS cameras come with variable zoom lenses. Their 35mm equivalents range from 20mm on the short, wide end to 100mm on the long, narrow end. Most offer a macro setting, which shortens the minimum focus distance of the lens.

In the days of yesteryear, PnS users dealt with small LCDs, which made it difficult to compose images. We also combated both digital and shutter lag in our picture-taking. These are problems of the past. Still, many of the following photos were taken using older equipment. I think this demonstrates that PnS underwater camera systems should not be discounted. Modern PnS cameras very much compete with the housed dSLRs in their ability. Take a look:

Following page, top—This photo of a Southern Stingray *(Dasyatis americana)* was taken in the waters of Key Largo using a 5MP Konica Minolta Dimage X-50 in its OEM clear polycarbonate housing. I used a black Sharpie to paint its front to mask the internal flash from affecting my picture-taking. I also jerry-rigged the connection for the strobe's fiber-optic cable. The Dimage had no manual settings, but I could fix the ISO, which I set to 100. I could select a white balance setting, as well; I used Sunny Day. The camera selected an aperture of f/6.7 and a shutter speed of $1/125$ second. My strobe, a Sea Life SL 960, had a rheostat-type control knob for power. I used it at around $2/3$ power. Bottom left—This Queen Angelfish *(Holacanthus ciliaris)* image was taken using the KMD from a distance of 3 feet. The Dimage has a focal length of 6mm but has a zoom feature with a 35mm film camera equivalent of roughly 35–105mm. The image was made without zooming, so the extrapolated focal length was around 35mm. The strobe used was Sea Life's SL 960. I kept its dial set at $2/3$ power. The ISO was fixed at 100, and the camera determined that an aperture of f/2.8 and shutter speed of $1/750$ second would produce a correct exposure. Bottom right—The Minolta Dimage in its OEM housing and SL strobe were used to capture my good friend during a dive on the Spiegel Grove, a ship sunk purposely for scuba diving. I used the lens at its widest setting to capture as much of my subject as possible. I was 3 feet from my buddy. Inside the wreck is darker than outside, so I turned the rheostat control to the full-power setting. Using this camera, I set the ISO at 100, and it does the rest. The camera set an aperture of f/2.8 and a shutter speed of $1/45$ second. This is a very slow shutter speed. The photo is in focus because my buddy stopped; also, the external strobe, when fired, helped to freeze action.

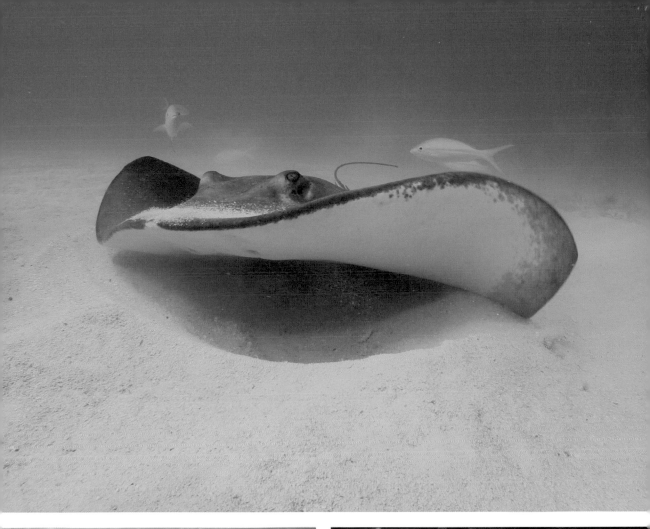

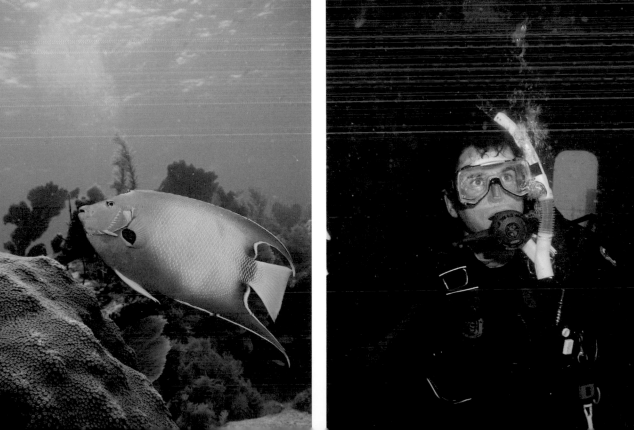

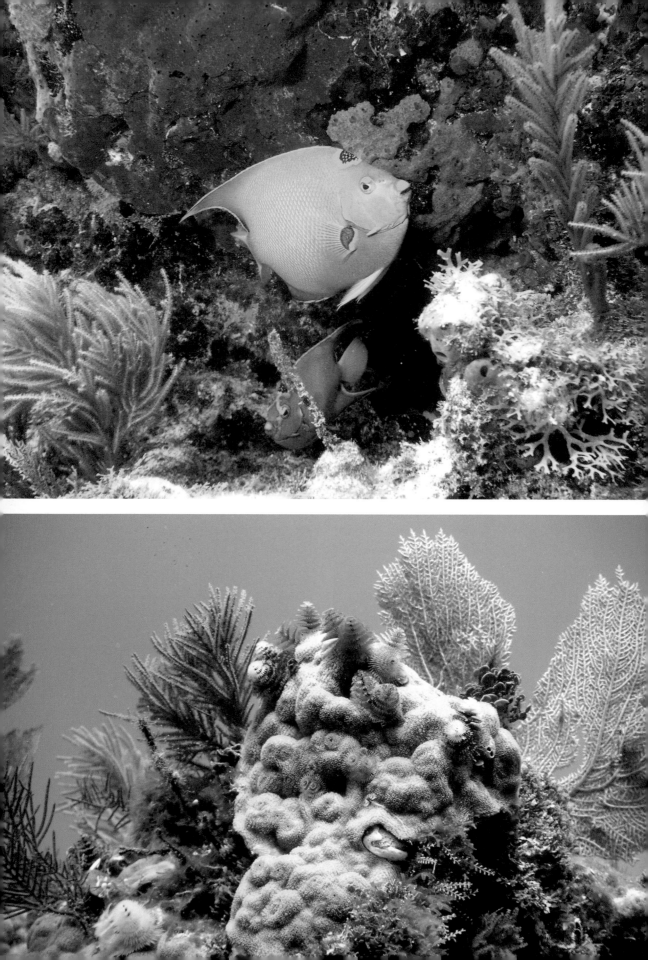

Previous page, top—The Queen Angelfish *(Holacanthus ciliaris)* is most often seen by herself, and of the Angelfish types is the most diver-skittish. She is also the most ornately adorned. I was lucky to find two Angelfish close enough together to fit in the frame of my Konica Minolta Dimage X-50. The pair was in motion, and it was a challenge to grab the shot before the scene dissipated. Out in the open water, my strobe was set to $^2/_3$ power. I try to keep the zoom at its widest setting, regardless of the camera or lens. This way, I know at what end of the zoom range I am at and can capture the most of any scene at the start of my shoot. This PnS is not full-featured. The camera set the exposure at f/2.8 and $^1/_{125}$ second. I set the ISO at 100, but the EXIF data revealed ISO 160.

Previous page, bottom—This reef scenic is about as large a reef scene as the limits of the X-50 will afford. On top of the Mustard Hill coral *(Porites astreoides)* were groupings of Christmas Tree Worms *(Spirobranchus giganteus)* extended and filter feeding. I managed to get within 2 feet of these and took my shot. Actually, I was able to take several shots before they retracted into their coral home. The strobe was at $^2/_3$ power. I set the ISO to 100 and the camera selected an exposure of f/4 and $^1/_{180}$ second. Above—This started out to be a head-on collision between this Gray Reef Shark *(Carcharhinus perezii)* and myself in the middle of a sand channel bordered by coral-encrusted walls. I'm not sure it saw me, as it veered to my right at the last second. I'd been framing it since I first saw it, so I was ready to grab a shot. I used my Dimage X-50. The Sea Life SL 960 strobe was at $^2/_3$ power. The camera acquired focus and set the exposure at f/5.6, $^1/_{125}$ second, and ISO 100. This shark was at the maximum distance for colorful underwater photography, 5 feet from me, and the coral ledge was even farther away. I worked with the image in postproduction to gain some contrast and saturation. The image would have been much nicer had these distances been shorter, but the shark determined that, not I. Still, the shot shows the possibilities and capabilities of a PnS camera system.

Top—Luck allowed me to produce a nice portrait of this Atlantic Spadefish *(Chaetodipterus faber)*, as the fish literally swam toward me as if curious. This photo was taken with a Konica/Minolta Dimage X-50 at a 1-foot distance. The camera automatically exposed at ISO 50, f/6.7, and $^1/_{180}$ second. The strobe was set at $^2/_3$ power. This camera and others offer an exposure compensation feature, which can be used to prevent overexposure and washed-out highlights. I used exposure compensation to underexpose this image by $^1/_3$ stop. **Bottom**—This photo of a giant Caribbean anemone *(Condylactis gigantea)* was taken

using a full-featured PnS. This is not a difficult capture, but the subject is not common in Florida Keys waters. The challenge is in finding one and making a nice composition and exposure. This anemone was about 1 foot across. My Olympus SP350 offered a My Modes (MM) feature, which allowed me to save four often-used exposure combinations (I set up two). This can be a time saver! I used my MM 2, which I set for macro. I also selected the macro setting on my camera to shorten the minimum focus distance of the lens. My strobe was set to TTL. The exposure was f/8, $^1/_{500}$ second, and ISO 100.

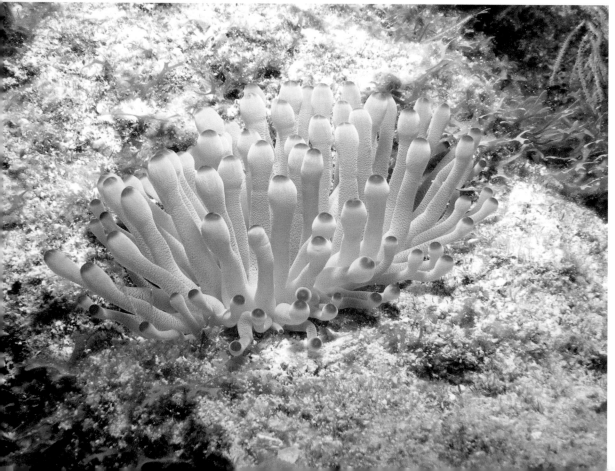

This image features a primary subject (the reef scene) and a secondary subject (the boat/dive ladder above). It is an example of getting into a good vantage point to get the maximum result of the camera's lens. I got below my main subject and shot at an upward angle to include the secondary subject in my frame. I was within 2 feet of the closest coral. I set the ISO to 100, the white balance to Sunny Day, and the exposure compensation to -.7 to prevent washed-out highlights. I could control my strobe output and dialed it down to $^2/_3$ power. The automatic PnS did the rest: the exposure was f/2.8 and $^1/_{500}$ second.

Top left—This is an example of a grab shot. This substantial sized Barracuda (*Sphyraena barracuda*) was high up in the water column and was shadowed by a snorkeler and tailed by another underwater photographer. I always glance around when engaged in underwater photography, so I saw this coming. I had my trusty "Oly" with me. It has the ability to store exposure settings as presets. I had one set to my starting-point exposure of f/5.6, $^1/_{125}$ second, and ISO 100. My strobe was at its starting point, too—full power—with a diffuser attached. I also had my wide-angle wet-lens mounted. The 'Cuda was seemingly preoccupied with the other divers, so I waited where I was, let it get closer, and composed my shot. I captured the fish as it veered away from me; we were separated by 2 feet of water at that moment. In this shallow water situation with plenty of bright ambient light, I spread the fingers of my

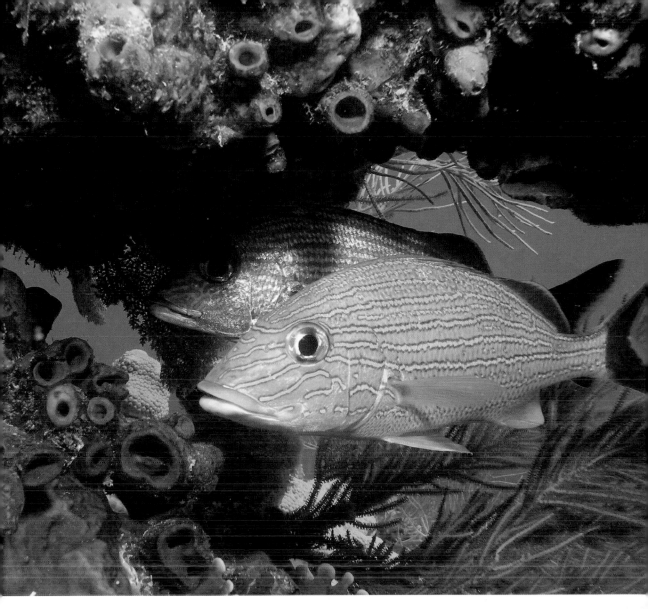

strobe hand and held them over the face of my strobe. Barracudas are very reflective, and I did not want to overexpose my subject. **Previous page, bottom**—An advantage to using a PnS camera is the versatility of their lenses. Their native lenses are variable zoom lenses, roughly ranging between a standard lens to telephoto angle of view. Many offer a macro setting, which reduces the minimum focus distance to a few inches or less. This photo of a Dragon Eel *(Enchelycore pardalis)* was made by Hector Sequin, Jr. off the coast of Oahu, HI. He took this photo using his Sea Life PnS DC 1000, set to its macro mode. Without using an external flash, the DC 1000 is fully automatic. The camera selected an exposure of f/6.3, $^1/_{100}$ second, and ISO 64 as Hector used its on-board flash. **Above**—The digital PnS cameras and their variable zoom lenses are excellent camera systems for fish photography. This is illustrated in this image of a pair of Blue-Striped Grunts *(Haemulon sciurus)* lodged in a coral hollow. I used an Olympus SP 350 in its OEM housing and a Sea & Sea YS-120 Duo strobe (connected via a sync cord) to take this photo. I manually exposed at f/5.6, $^1/_{125}$ second, and 100 ISO and a diffused strobe at $^1/_2$ power. My distance was 2 feet from the fish. I removed my wide-angle wet-lens and used the camera's native lens, a 38–114mm 35mm equivalent, set to 38mm.

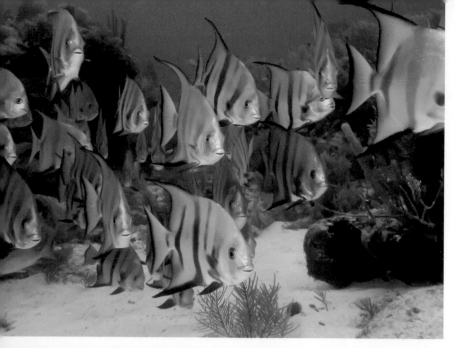

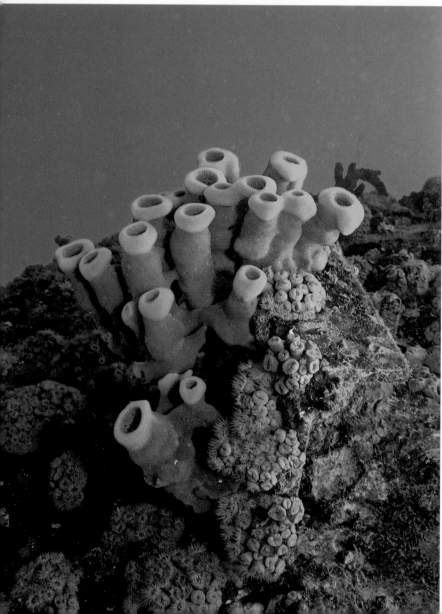

Top—I took this photograph of this school of Atlantic Spadefish *(Chaetodipterus faber)* who live on Molasses Reef off the shore of Key Largo, FL. I used my Olympus SP350 with my wide-angle wet-lens to capture the whole school. I had a single YS-120 Duo strobe, diffused and set to full power. The exposure was f/8, 1/100 second, and ISO 100. I was approximately 3 feet from the fish. Spadefish are very reflective. I wanted to light the whole scene, so I used the diffuser to spread my strobe beam and soften its light. I chose a smaller aperture, f/8, rather than my normal starting-point aperture of f/5.6. **Bottom**—This reef scene of sponge and cup corals was photographed with my full-featured Olympus SP350 in manual mode. I attached my wide-angle wet-lens so I could capture the whole scene from a close enough distance to get good color. I used a single strobe positioned above my system and shot in the portrait format. When I use only one strobe, it is mounted on my left-hand side. So when I shoot in the portrait format, I want to remember to turn my system so the strobe is on top and I light my subject from above. I use strobe only to restore color, and when I do it correctly it is difficult to see whether a strobe was used. Natural light comes from above, so that is where I want my strobe positioned relative to my subject. I exposed this scene at f/4.5, 1/60 second, and ISO 100.

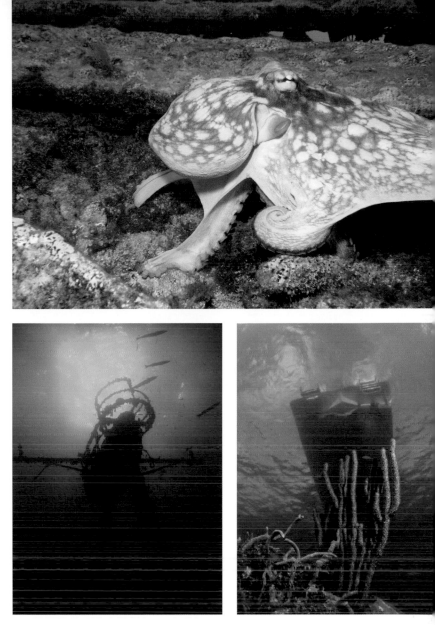

Top—An Octopus *(Octopus vulgaris)* out in the open in broad daylight is an unusual sight. I was photo-diving on the wreck of the City of Washington and this nice-sized (8 to 10-inch diameter body) specimin was scooting across the deck of the wreck looking for a new hide. I was equipped with a PnS camera that alllows for manual exposure settings. I used the camera's native lens and didn't have a wide-angle wet-lens adaptor employed. I ordinarily do not like shooting at a downward angle because I do not get nice separation between my subject and the background. In this case, I took what Mother Ocean offered. I got within 2 feet of the Octopus with the variable lens set to its widest view of 38mm (35mm film equivalent) and made the exposure with one diffused strobe at full power. The exposure was f/6.3, $^1/_{125}$ second, and ISO 100. Bottom left—This silhouette image was made using a PnS with no manual exposure controls (just the ISO and white balance). I usually select an ISO of 100. In this instance, I used the auto white balance option. Note, though, that different PnS cameras render different white balances; experiment to find out which setting produces the most realistic colors. In this setting, I stayed far from my subject, the crow's nest on the USS Duane, so it would be impossible to get color. I positioned myself so my side of the subject would be in the shadow of the sun. I turned my strobe off, as no strobe is used when making a silhouette image. The camera chose an exposure of f/6.7, $^1/_{350}$ second, and ISO 50. I suspect the camera metered off the lighter, brighter, area of the scene. Bottom right—When I migrated from film to digital, I remained (initially at least) a wide-angle guy. One reason why is the types of photos I can take with wide-angle lenses, like this near/ far photo of a Sea Rod as my primary subject and dive boat as the secondary subject. I used my SP350 and its wide-angle wet-lens adaptor and a single diffused strobe to light my primary subject and let the boat fall into silhouette, or near silhouette, in the background. The exposure was f/6.3, $^1/_{125}$ second, and ISO 100. I was about 2 feet from the coral and shot almost straight up toward the dive boat.

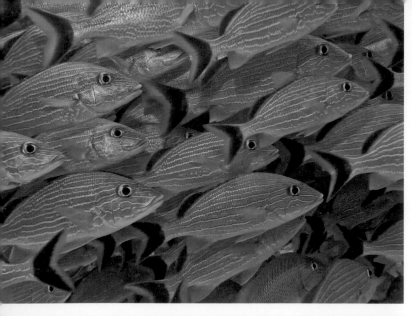

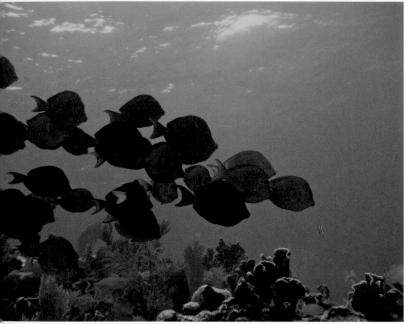

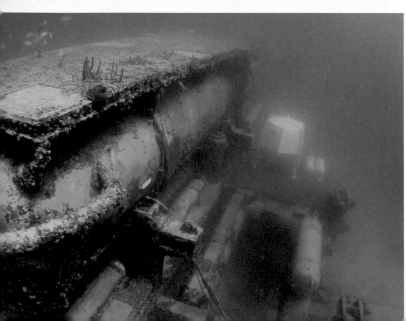

Top—For this "fish-pack" shot of Blue-Striped Grunts *(Haemulon sciurus)* I used the native and wide 28mm end of my full-featured PnS camera's lens to fill the frame with nothing but fish. I was able to get within 3 feet of the school. I used one strobe. The exposure was f/8, $^1/_{100}$ second, and ISO 100. **Center**—There is a trick to capturing a school of Blue Tang *(Acanthurus coeruleus)* as they dance from one coral formation to another in their feeding mode: you've got to guess which coral formation they are headed for and try to meet them there, ready to shoot. This trick applies to any school of fish found in the open water and fleeting across the top of the reef. I got a good vantage point in this photo and made the shot using an automatic PnS with one strobe, diffused and at full power. The camera set an exposure of f/2.8, $^1/_{500}$ second, and ISO 100. **Bottom**—All types of subjects can be photographed with PnS underwater camera systems. This is a section of the Aquarius, an undersea habitat used for oceanographic research, which sits in 60 feet of water on Conch Reef in the waters south of Key Largo, FL. I used my full-featured PnS and its wide-angle wet-lens with ambient light only to take this image. Given the distance I was shooting from, a strobe would not have helped make this image. The exposure was f/4.5, $^1/_{80}$ second, and ISO 100. I used a large aperture and slow shutter speed to offset my not being able to use my strobe.

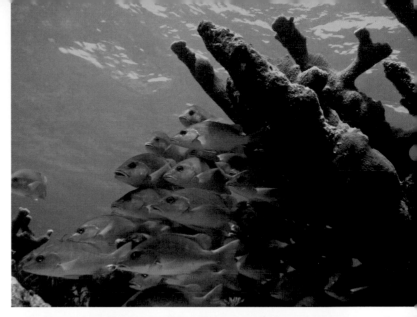

Top—This is a nice setup for a camera with a wide to semiwide angle of view lens. We have the elements—a school of fish (Schoolmasters, *Lutjanus apodus*), coral (a stand of Elkhorn, *Acropora prolifera*), and water—that viewers appreciate if not expect to see. This was taken in the waters of the Florida Keys on the Elbow Reef. I used a simple PnS camera and one strobe, diffused at $^2/_3$ power. The lens was set to its widest angle of view, and I shot from 3 feet. The exposure was f/2.8, $^1/_{750}$ second, and ISO 100. The photo was made in roughly 20 feet of clear water on a sunny day. Center—Scenic elements can be used to frame the subject, here, three Schoolmasters *(Lutjanus apodus)*. If there is a trick to it, it is hoping the fish stay put until you get close enough to take the shot. Move in slow, have the camera up to your eye before you arrive, and do not make eye contact with fish along the way. I used a diffused strobe centered above my camera and a wide-angle wet-lens. I was just over 2 feet from the scene when I took this shot. It was a bright day and I was in 25 feet of water, so I tightened my aperture to f/8. The shutter speed was $^1/_{125}$ second and the ISO was 100. Bottom—PnS systems—especially those with a manual mode and wet-lenses—have been unjustly snubbed by some underwater photographers. The ability to change lenses underwater is a huge advantage over a dSLR. This photo of a school of Schoolmasters *(Lutjanus apodus)* was taken in 20 feet of water in Bonaire. I used a PnS camera with a strobe set at $^1/_2$ power. The lens had an angle of view of almost 80 degrees, and the fish were about 3 feet in front of me. The exposure was f/6.7, $^1/_{125}$ second, and ISO 100. I enhanced the image a bit in Lightroom.

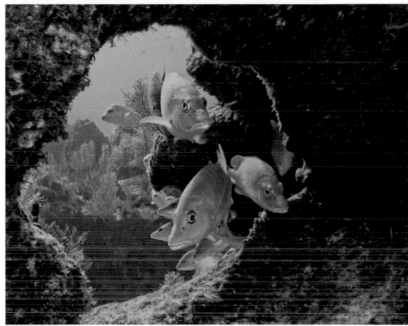

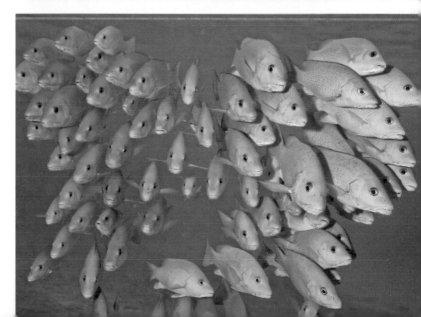

THE MID-RANGE ZOOM LENS

A mid-range zoom lens is a handy tool for underwater photographers. It offers photographers the opportunity to photograph a wider variety of subject sizes by changing focal lengths on the go. With a mid-range zoom, we can capture small, medium, and large subjects with just one lens!

Let's take a look at some images made with mid-range zoom lenses so that you can get a feel for what they are capable of.

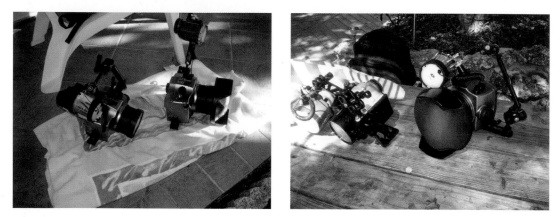

Left—In topside photography, photographers seem to have a favorite day-in-day-out, walk-around lens. The mid-range zoom lens is my underwater version of that lens. I shoot with a cropped-sensor camera, and my lens of choice is the 18–55mm. Sigma's 17–70mm is another popular choice. Its minimum focus distance is less than 12 inches, and it can be used behind a dome or flat port. Full-sized sensor camera owners might use a variable zoom lens in the 24–70mm or 16–35mm range. An alternate option for both cropped-sensor and full-frame camera users is a lens with an angle of view equivalent to 15mm or 20mm (80 degrees +/-). These lenses are considered mid-range because their widest angle of view (shortest focal length) is not ultra-wide and their narrowest angle of view (longest focal length) is not considered macro or telephoto. It is a good choice for shooting a variety of different-sized subjects. These prime lenses can also be used behind either a dome or flat port. Right—As mentioned, mid-range zoom lenses can be used behind a flat port or a dome port. Using it behind a flat port will decrease the lens's angle of view due to refraction of the water. This is to our advantage when shooting small subjects (they will appear larger and closer), but our angle of view will be narrower at the shorter, wider, end of our zoom range. With a dome port, the native angle of view of the lens is maintained. Many shooters start out with a flat port and later add a dome port because dome ports are 2 to 3 times the cost of flat ports. I like to set my mid-range zoom lens to the widest angle of view (for my lens, it's 18mm) and adjust as necessary (but I prefer to "zoom" with my fins). I return the lens to its widest angle of view when I am finished taking my photo. A person could use a starting point at the other end of the lens range; it's just important that you pick an end and habitually start there. The time it takes to figure out where you are in your lens range can mean the difference in getting your photo or not. I also have a starting-point exposure that works at depths of up to 40 feet. These settings—f/5.6, $^{1}/_{125}$ second, and ISO 100—will get me in the ballpark most times when a subject appears out of the blue. My strobe is set at full power, with a mounted diffuser. I almost invariably use auto white balance when using my strobe.

Right—This photo of a stand of Branching Vase Sponges *(Callyspongia vaginalis)* was taken in Bonaire using a Canon dSLR in a Watershot housing. The lens was a variable zoom with a focal length of 18–55mm and was behind a small, 5-inch dome port. The lens was set to its widest angle of view, 18mm. The exposure was made using one strobe at full power. My distance from the subject was just over 1 foot. The exposure was f/8, $^1/_{90}$ second, and ISO 100. The subject is taller than it is wide, so it was photographed in the portrait format. **Below**— This photo was taken using a Watershot-housed Canon dSLR and 18–55mm lens set at 55mm, with a flat port. These Christmas Tree Worms *(Spirobranchus giganteus)* were separated from their surroundings as I photographed from a vantage point of straight across and a slightly upward angle. With the lens set to 55mm, the depth of field is shallow, and the background blur also helped to create separation. The exposure was f/9.5, $^1/_{125}$ second, and ISO 100. I used a single strobe set to TTL and shot from a distance of just under 1 foot.

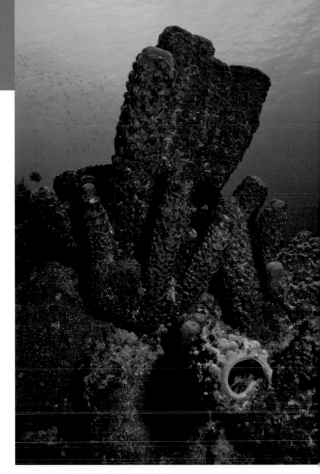

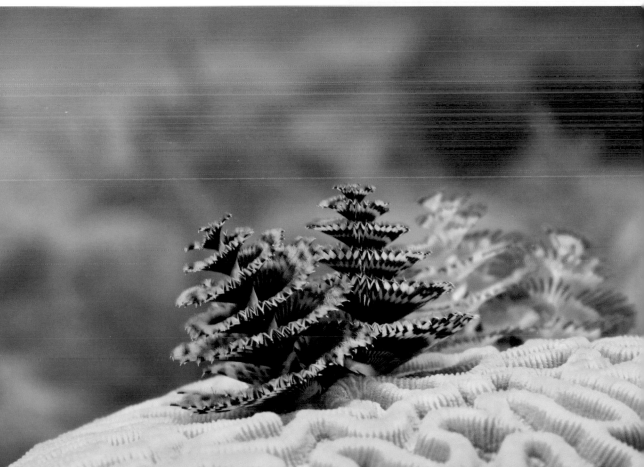

Top—This is a capture of behavior. The fish, a Blue-Striped Grunt *(Haemulon sciurus)*, is taking a posture of protecting its space. Most times we see this fish do this once, and before we are ready. This time, it repeated its behavior, and on its third gesture, I was ready and grabbed the photo with my housed dSLR and 18–55mm lens behind my large 6-inch dome port. I shot with a single strobe. The exposure was f/6.7, $^1/_{125}$ second, and ISO 100. To keep some distance, I zoomed in to what turned out to be 39mm and shot from about 1$^1/_2$ feet away. Bottom—The mid-range zoom lens is great for taking photos of small groups of divers because it can capture the whole group at a close enough distance to ensure good color. This photo was taken in 60 feet of water; at that depth, we lose 2 f-stops worth of ambient light. A rule of thumb is we lose one f-stop's worth of ambient light per ATA (atmospheres of pressure, or, every 33 feet). This photo was made using my 18–55mm lens at 18mm behind a dome port. I used a single strobe at full power and removed its diffuser, knowing I had lost ambient light at this depth. My manual

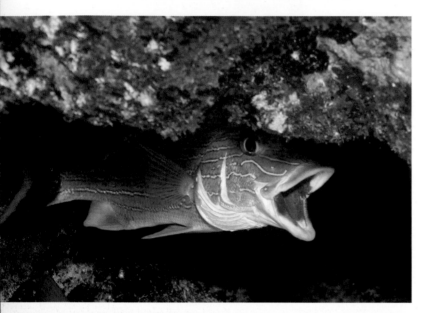

exposure settings were f/6.7, $^1/_{125}$ second, and ISO 100. The lens's wide angle of view enabled me to take this photo at a little over 2 feet of distance from me to the first diver. Following page—I captured this stand of Pillar Coral *(Dendrogyra cylindrus)* with my housed Canon dSLR, 18–55mm lens at 18mm, and 6-inch dome port. It is taller than it is wide, so I composed in the portrait format. I shot at an upward angle to lend a little life and drama to the scene. I was positioned a little over 1 foot away from the coral. I made the image using one strobe, for top lighting. The exposure was f/6.7, $^1/_{125}$ second, and ISO 100.

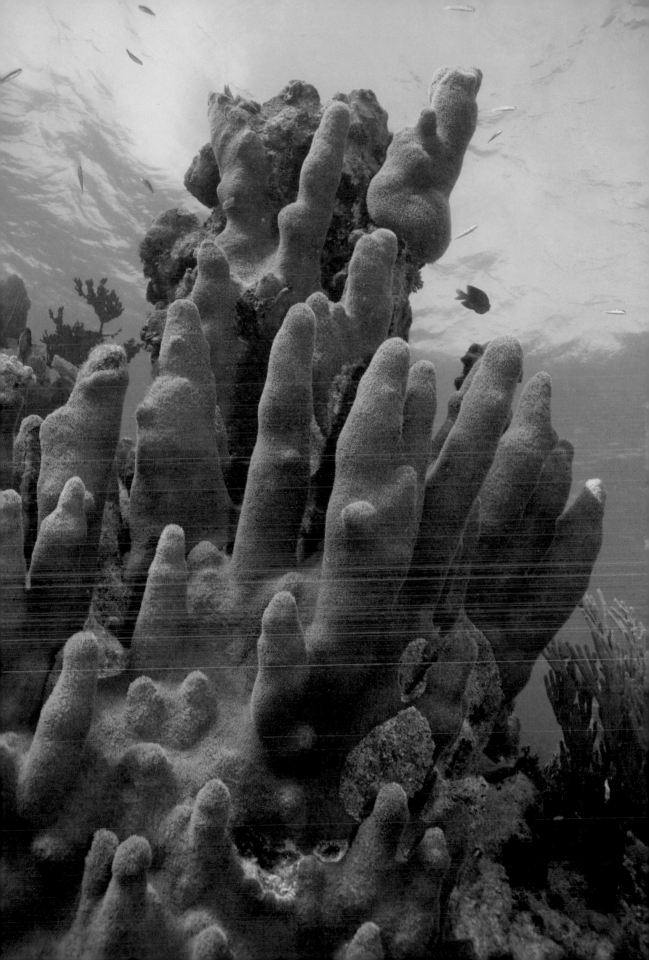

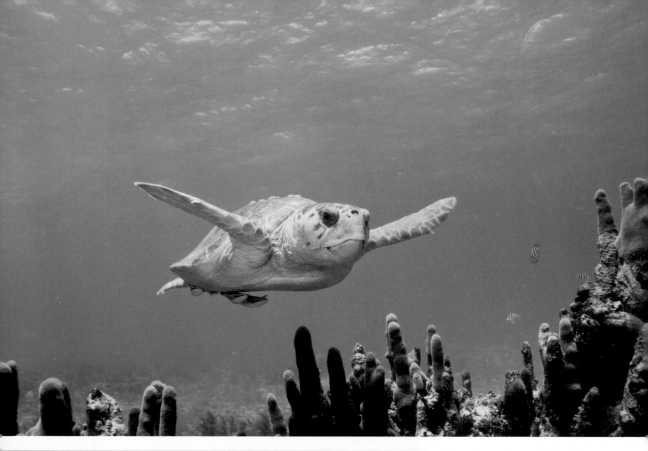

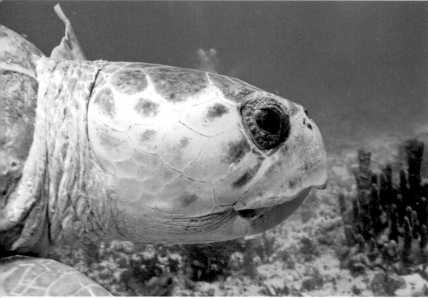

Top—I was photo diving Pillar Coral reef off shore from Key Largo, when along came this Kemp's Ridley Sea Turtle *(Lepidochelys kempii)*. I was able to wait as the turtle headed my way. I used a single strobe at full power. I had time to adjust my exposure settings while the turtle swam closer, and I shot at f/8, $^1/_{90}$ second, and ISO 100. It does not look like it, but the turtle came within a foot from me when I pressed the shutter release. **Bottom**—This follow-up shot was taken 2 seconds later, as the turtle cruised by as if I wasn't even there. The exposure was the same, but I moved my strobe back almost 1 foot. This helped to not overexpose my subject. There was no time to dial in a smaller aperture.

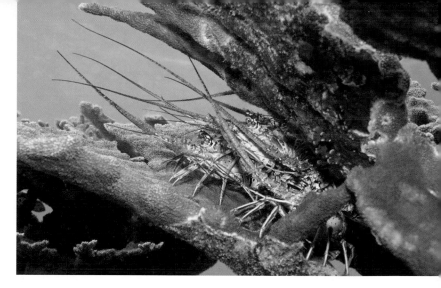

Top—I found these Spiny Lobsters *(Panulirus argus)* perched up in the Elkhorn coral (Acropora prolifera) in the waters of the Key Largo National Marine Sanctuary. They are protected there. I've seen lobsters nearly everywhere but here. They are usually tucked away nearer the bottom of the reef in recesses in corals. I photographed this with my housed dSLR and trusty 18–55mm lens. I was able to move in close, a little over 1 foot away, then zoomed to a 34mm focal length to fill the frame for a better composition. This photo was taken with a single strobe and using my dome port. The manual exposure settings were f/5.6, $^1/_{125}$ second, and ISO 100 (my starting-point exposure). The strobe was set at full power. **Bottom**—I took this photograph of a reef scene in Belize on a Wall dive. My lens was at the 18mm focal length to get as much of the scene in the frame as possible. I composed the shot with three elements in mind—the tube sponge would be the main subject, the Deepwater Gorgonian would be the background, and I would shoot from a slightly upward angle in order to bring the water column into play as the third element. My manual mode camera settings were f/5.6, $^1/_{90}$ second, and ISO 100. My single strobe was at full power and diffused. I shot at just under $1^1/_2$ feet from the sponge.

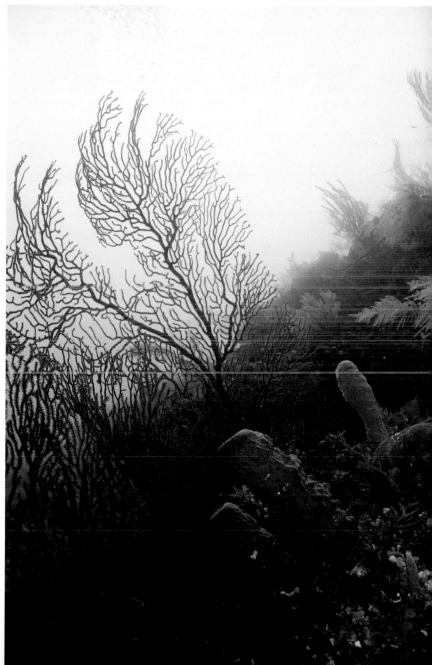

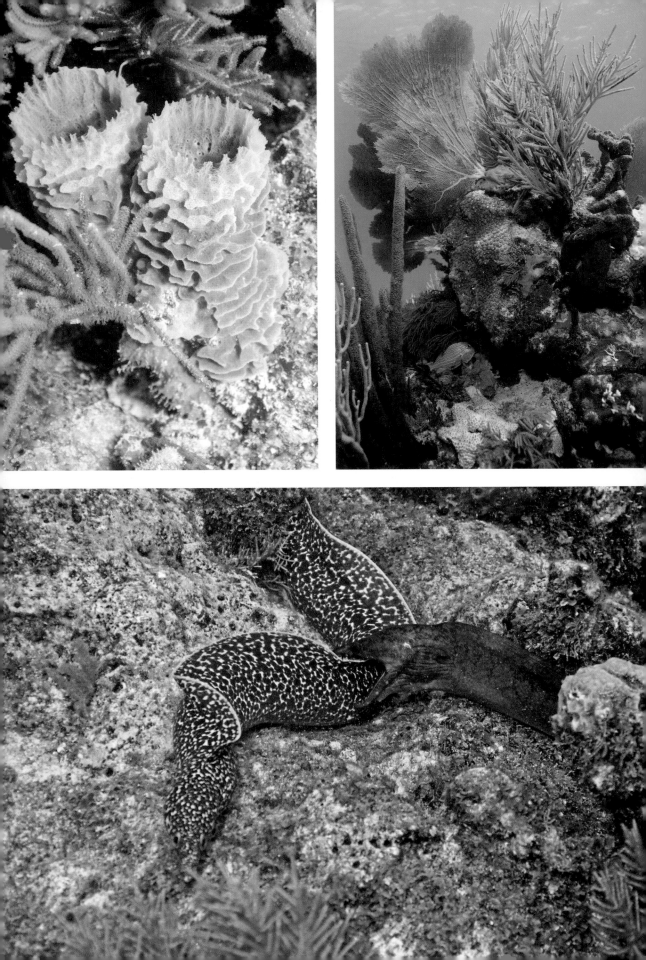

Previous page, top left—This Azure Vase sponge *(Callyspongia vaginalis)* scene was photographed in Key Largo. I love the color, and it is tough to not wash it out with strobe. Its shape and color naturally separates it, so I concerned myself with capturing the sides and openings at the top. My EXIF data tells me I shot this with a focal length of 50mm and manually exposed at f/6.7, $^1/_{125}$ second, and ISO 100. I was 1 foot from my subject. As I knew that I could wash out the sponge's color with too much strobe, I set my strobe to TTL. In TTL mode, the strobe will fire at full power or something less than full power. Previous page, top right—The colors found on coral reefs are what got me interested in diving. I can't resist taking a photo of corals when I see lots of colors together in one scene, as was the case here. In this scene, things were more up and down than left and right, so

I shot in portrait format. With an upward angle, I got some negative space (the water) in my composition; the blue complements the rest of the colors in the scene. I manually exposed at f/5.6, $^1/_{125}$ second, and ISO 100. I used one strobe at full power, with a diffuser. The shutter speed governs the background in our photos—the lightness or darkness of the water. If I wanted the water column darker, I could have used a shutter speed faster than $^1/_{125}$ second, such as $^1/_{180}$. The coral was a little over 1 foot from my dome port, and the focal length was 18mm. Previous page, bottom—This shot of marine life behavior shows the importance of having a starting point for exposure. Here, I was able to capture a pair of Spotted Moray Eels *(Gymnothorax moringa)* battling over territory. The left eel wanted the spot that the right eel occupied. I didn't have time to zoom with my fins, so I zoomed to the 55mm end of my lens and fired away. My strobe was diffused and set at full power. I had my camera set to my starting-point exposure settings—f/5.6, $^1/_{125}$ second, and ISO 100. The white balance was set to auto, and I shot from about 4 feet. Above—Here is another reef scenic I photographed in Roatan while leading a small group there. Roatan is a dive mecca because of its abundance of live corals, including this larger-than-me Giant Barrel sponge *(Xestospongia muta)*. I framed it in the portrait format and used my strobe, at full power and with a diffuser, to light it from the top. I chose an upward angle to add separation; the shadow from the single strobe helped with that too. The manual exposure settings were f/4.5, $^1/_{125}$ second, and ISO 100. I shot at 18mm from a distance of 2 feet. I opened the aperture up from my normal setting, as there was less ambient light due to the water's depth and the sky was partly cloudy.

Top left—Here's another shot of what is probably my favorite sponge, the Azure Vase sponge *(Cally-spongia vaginalis)*, along a Wall at Roatan. Viewers of our underwater images tend to look for two things: water and fish. We can usually give them water, but not always a fish. To me, a pleasing reef scene doesn't necessarily need a fish. Here, I substituted the fish with the sponge. I always taught my students, if you see something that looks pretty to you, take its picture! Light was added with a single strobe. The manual exposure settings were f/5.6, $^{1}/_{125}$ second, and ISO 100. The lens was set at 18mm, and my distance from the sponge was approximately $1^{1}/_{2}$ feet. **Bottom left**—The Lionfish *(Pterois volitans)*, to my eye, is one of the most ornate fish there is to photograph. They are indigenous to the Indo-Pacific waters. They are said to have "invaded" our waters ten years ago (yes, they are considered an invasive species). Actually, they did not invade anything. Rather, they were transported here in ships' bilges and also released in the wild by aquarists. I was initially fearful that I would

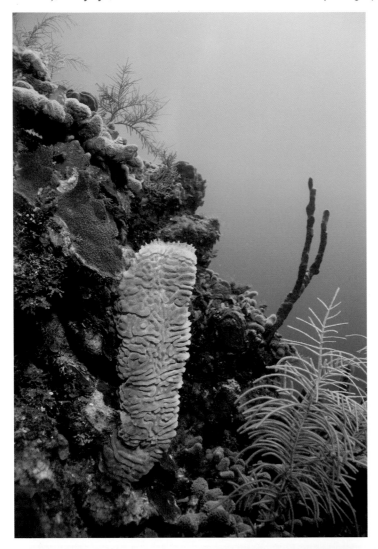

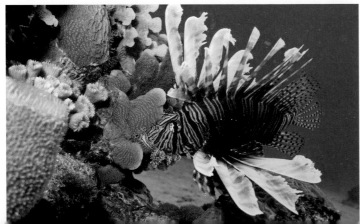

not get a photographic capture of this fish before they were hunted down and eradicated. However, they now are easily found and sighted in all of the waters of the Florida Keys, Bahamas, and the Caribbean. This rather large specimen was photographed while I was diving in Roatan, Honduras. They are a predator with venomous spines and, as such, are not at all skittish. I was able to maneuver to a vantage point to make a nice composition. I used a flash at full power, fitted with a diffuser. My exposure was f/8 and $1/125$ second. I tightened up my aperture from my starting point of f/5.6, so I decided to reciprocate for the lost light by increasing my ISO to 200. I zoomed in a tad from 18mm to 32mm to better fill my frame with the fish. I was a bit over 1 foot away and thought if I tried to get any closer, the fish might turn away from me. **Below**—I stumbled across this Scorpionfish *(Scorpaena plumieri)* in Key Largo. They stay pretty much parked where you first see them and are not too skittish. For that reason, I had time to move around to the front of the fish and get fairly close. I zoomed to 55mm and took a couple shots. I had one strobe, set at full power, and moved it to center over my camera housing. I used an f-stop of f/13—much more narrow than my starting-point aperture of f/5.6—because I was less than 1 foot away from the subject. I chose a shutter speed of $1/60$ second to reciprocate for the smaller aperture in order to produce a nice exposure. I left the ISO at 100. I took more than one shot of the Scorpionfish becasue the scene was set. I tinkered with my exposure settings between those shots. I call this photo *These Eyes.*

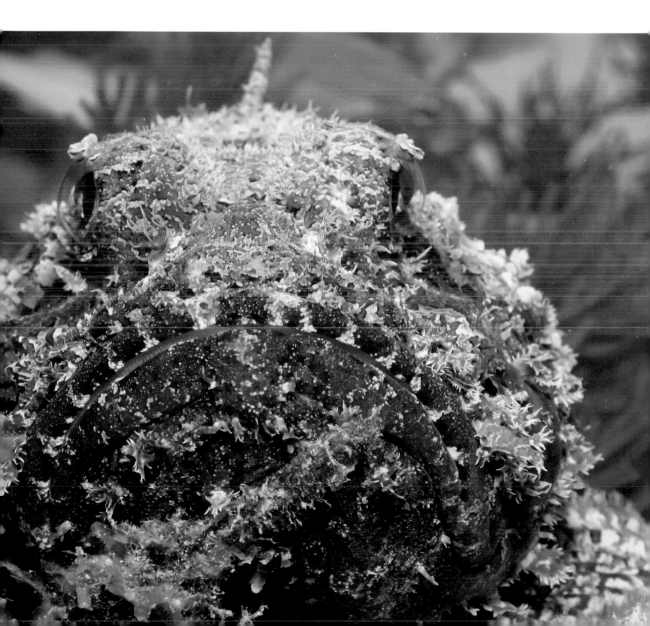

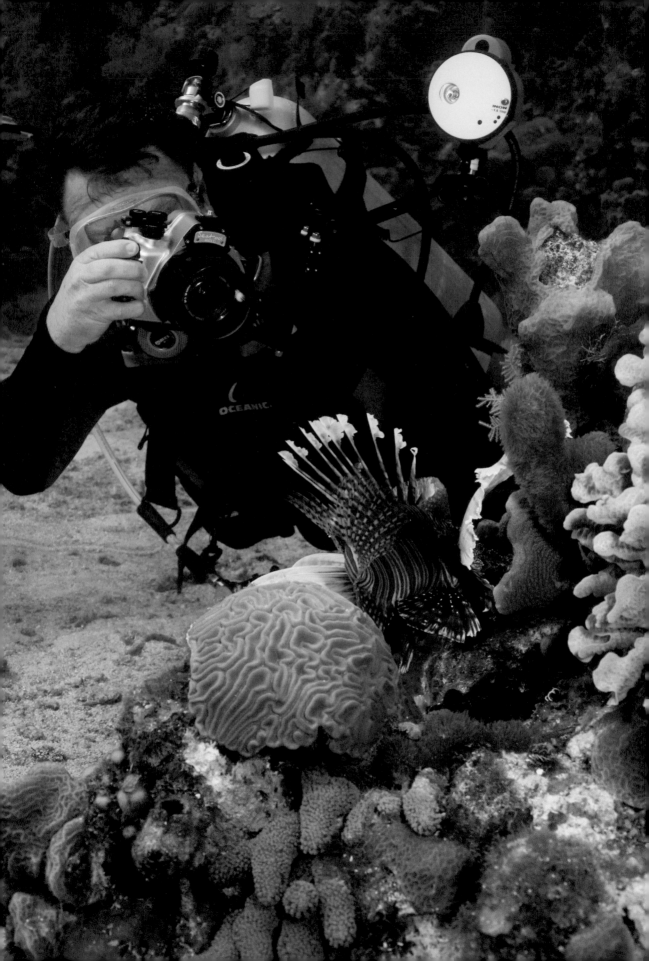

Previous page—When you can't find anything else to photograph, there is always your dive buddy! Photographing a friend is even better if you can capture your buddy doing something that tells a story. In this case, my buddy edged me out of my shot of this Lionfish we found in Roatan. I did not want him in the background. I decided to make the best of the situation and got both the shot of Steve and "his" Lionfish. I had my housed dSLR and a 18–55mm lens. I shot at the short (wide) end, at 18mm, and behind my small dome port using full-powered strobe. I tightened up my aperture from f/5.6 to f/8 so I could get both the fish and Steve within the range of focus. Due to the loss of light that resulted from the aperture change, I boosted my ISO from the normal 100 to 200. The shutter speed was $^{1}/_{125}$ second. I was just under 2 feet from the Lionfish. **Below**—This image of a Pederson Cleaner Shrimp *(Ancylomenes pedersoni)* is an example of the range of possibilities a mid-range zoom lens presents. This shrimp is less than 2 inches at its longest measurement. They are difficult to see and to find. I find them by looking for Corkscrew Anemones, which are softball-sized and easier to see and a favorite hangout for the Pederson Cleaner Shrimp. I was using the lens behind my flat port and with one diffused strobe. I zoomed from 18mm to 55mm because of the small size of my subject and switched the strobe from full power to TTL to try to avoid overexposing the image. I positioned my strobe above my housing from the left side. I was 1 foot away, which is the minimum focus distance of the lens. The manual exposure settings were: f/9 (I tightened up from f/5.6, again to not overexpose), $^{1}/_{125}$ second, and ISO 100.

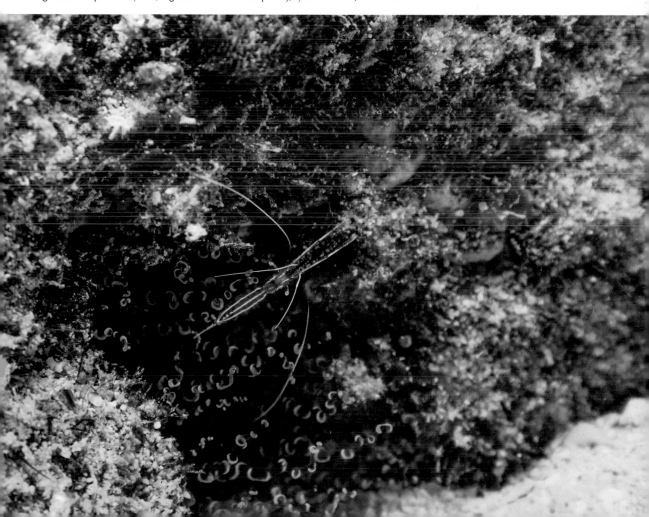

Top—The versatility of a mid-range zoom, like the 18–55mm, shows itself again in this photo taken with the whole diver in the frame. At its widest angle of view, the lens can capture whole divers or small groups of divers with the photographer being close enough so that the reds are not absorbed by the water column. This photo was taken just as the dive was getting underway in Roatan. I shot in manual mode, and my exposure settings were f/5.6, $^1/_{125}$ second, and ISO 100. My strobe was diffused and used at the full-power setting. My camera-to-subject distance was just less than 3 feet. Bottom—This pair of divers in Roatan were photographed in 30 feet of water, again using my "dive around" 18–55mm lens set at 18mm behind my dome port. I was within 2–3 feet of these two and made my exposure using a full-powered, diffused strobe. I set the aperture to f/8, the shutter speed to $^1/_{125}$, and used an ISO of 100.

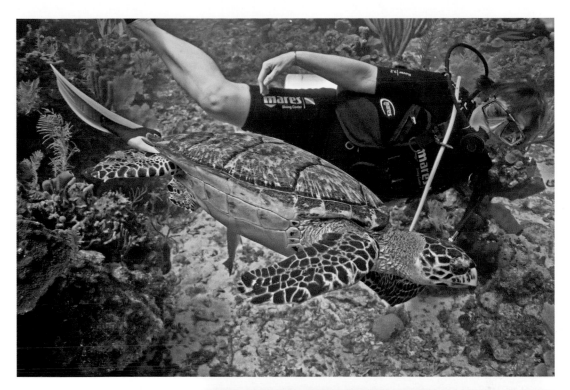

Top—Our group spotted this Green Sea Turtle *(Chelonia mydas)* and I was the closest member to it but not close enough to get its photograph. Other members of the group vied for a better, closer view and inadvertently herded it, causing it to change its course. Seeing its new course, I set out to intersect it in order to get close enough for a shot and to get a good van tage point. I did not have a great vantage point because I was

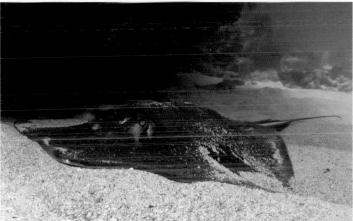

shooting down at my subject and the background below and behind the subject obscures it when we do that. Time was running out; fortunately, my buddy Wendy swam into the frame and made the composition for me. I made the shot with my dSLR and 18–55mm lens set at 18mm. I had one strobe mounted and fired it at full power, though diffused. I took the shot from a distance of 2 feet. My manual exposure settings were f/5.6, $\frac{1}{125}$ second, and ISO 100. Bottom—This photo of a Southern Stingray *(Dasyatis Americana)* was taken in Key Largo, FL. It swam into the framed area from the background and had just settled into the sand under a coral ledge. I waited until it got settled, then moved its way beginning from a distance of at least 40 feet. As I got closer, I began to shoot, fearful that the ray might decide to relocate before I got into an ideal position. Slow movement on my part and patience rewarded me. I was able to get within 2 feet of the ray and took this photo. I made the exposure at 37mm with my 18–55mm lens, dome port, and a single strobe. My manual exposure settings were f/8, $\frac{1}{125}$ second, and ISO 100.

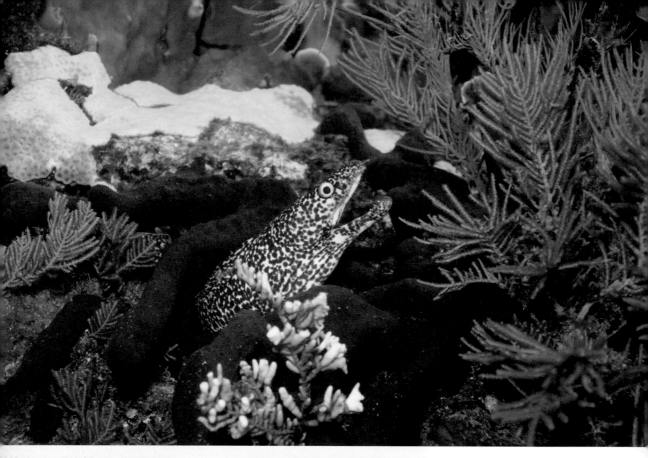

Top—I was anxious to make this image of the Spotted Moray Eel *(Gymnothorax moringa)*, which I judged to be a small one at 2 feet or so in length. I first saw it moving across the top of the corals and then it slithered into and among them and was very active. I moved toward it and, moving from a wide sand channel to the corals, the eel completely disappeared from my sight. I had my manual exposure settings at f/5.6, $1/125$ second, and ISO 100. I used my dome port and a single diffused strobe. I kept heading to where I last saw the eel, and it reappeared among the wine-colored Rope Sponges. I was not as close as I wanted to be but brought my camera to my eye, zoomed in from 18mm to 55mm, and took the shot before it disappeared again. Sometimes it pays to be ready. **Bottom**—This image of an Arrow Crab *(Stenorhynchus seticornis)* that will easily fit in the palm of your hand really shows the versatility of a good walk around/dive around lens like the mid-range zoom. At first glance, you'd guess that

I had zoomed to the 55mm end of the lens's range. But, my EXIF data surprised me, as it shows the lens was at 18mm, its widest setting. I ordinarily would have set the lens to 55mm before making my approach. I have no explanation as to why I left it at 18mm. The manual exposure was f/5.6, $^1/_{125}$ second, and ISO 100. I shot with a full-powered, diffused strobe. I took the photo from a distance of 1 foot. I moved the strobe on its arm back toward me in order to reduce its output. A change of 1 foot in strobe-to-subject distance (either closer or farther) equals a change of an f/stop's worth of exposure value. **Right**—On this dive off the shore of Key Largo, we had 100 feet of visibility. The subject, *Christ of the Abyss*, is a coral-encrusted 9-foot-tall bronze statue. It rests in a narrow sand channel bordered by coral walls and in 20 feet of water. It is one of the most widely photographed subjects in the Florida Keys. On this day, I took its photograph with my housed dSLR and my lens set to 18mm. My exposure settings were f/6.7 (I closed down my aperture because of the good visibility, shallow water, and amount of ambient light), $^1/_{125}$ second, and ISO 100. I was approximately 3 feet from the statue.

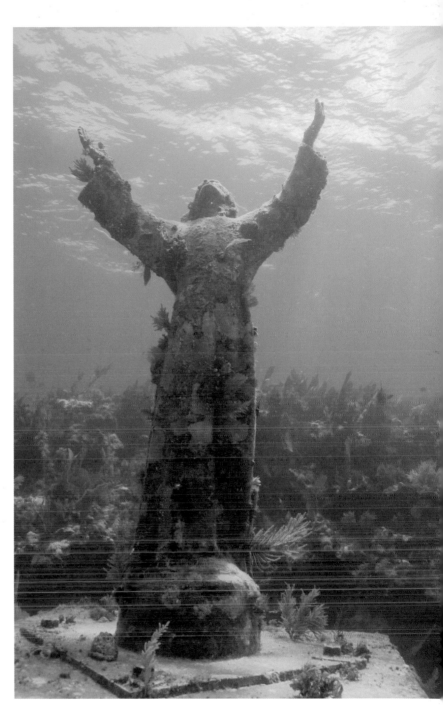

THE 60MM MACRO LENS

Most photographers who use a dSLR for underwater photography choose to add a macro lens to their lens inventory. (PnS camera users can use a macro setting or a wet-lens macro adaptor; they have their bases covered.) Let me tell you about my journey to using a 60mm macro.

In 1992, I bought a used Sea & Sea Motormarine II camera from a young man recently discharged from the Navy. This camera is an amphibious (no external housing) 35mm range-finding (you guesstimate and set the focus distance) film camera. It has a fixed 35mm lens. The camera has an automatic setting and can be used in manual mode. However, it has a fixed shutter speed of $^1/_{100}$ second and only two choices of film speeds: ISO 100 and ISO 200. I could select the aperture (f/3.5 to f/16). The camera also has a built-in flash, but with

limited power. It has TTL capability (i.e., it can communicate with its dedicated external strobe to automatically adjust the strobe's output). TTL was an advanced technology at that time, but it was somewhat unreliable in function.

Given the Sea & Sea's fixed 35mm lens, photographers had to contend with a very shallow depth of field. This, plus the fact that users had to guesstimate the distance to focus, made getting a sharp image difficult. To solve this problem, I purchased a wide-angle lens adaptor to accomodate shorter focal length lenses, such as 20mm and 15mm. These lenses yield a wider depth of field, so more of my shots were in focus. I became a "wide-angle guy" and took to shooting larger subjects suited for the wider angle of view of my lens. This was my mode of opertation until I bought my first digital camera—a

The 35mm lens on my Sea & Sea camera offered very limited depth of field, plus I had to guesstimate the distance. This made getting shots of Christmas Tree Worms *(Spirobranchus giganteus)* difficult.

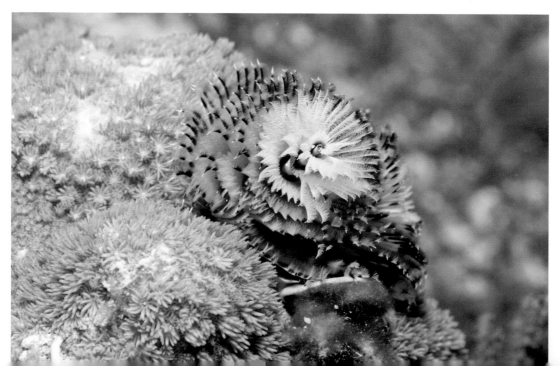

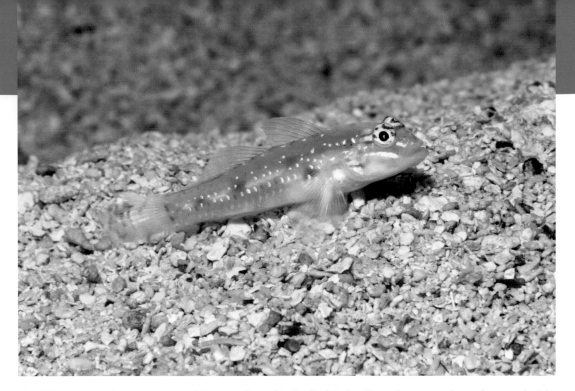

The 60mm macro lens captures subjects such as this Bridled Goby *(Coryphopterus glaucofraenum)* with a narrow enough angle of view so the Goby fills a nice percentage of the frame. The exposure data was: f/13, $^1/_{125}$ second, and ISO 100. When shooting close, I can tighten my aperture. Here, I went from f/5.6 to f/13 so as to not overexpose sand particles or the Goby.

PnS—about ten years later and discovered I could shoot the very small subjects living on the coral reef.

Soon after, I purchased a full-featured PnS camera and built an underwater photography system around it. This camera offered manual exposure control and a macro setting.

I became more intrigued with shooting small subjects, but it wasn't until I obtained my first dSLR in the mid 2000s that I delved into macro photography. I chose a DX camera because of its cost, smaller size, and light weight. I liked the housing and its price, too. I had a mid-range zoom for the dSLR; it had a wide enough angle of view at its short end to satisfy my habit for shooting wide angle, but all the cool kids were shooting macro, and I figured they might have a point.

The macro lens of choice for a Canon cropped-sensor dSLR is Canon's 60mm macro. I think the Nikon equivalent is their 50mm macro. These lenses are widely supported by manufacturers of underwater photography gear. Also, the 60mm (or 50mm) lens is easier to use than a 100mm lens and is less expensive, too.

My photos in this chapter were made using my full-featured PnS camera system's macro settings or my housed dSLR camera and the 60mm macro lens. Contributing photographers used their preferred macro setups.

Macro photography is a hoot to shoot. It opens up a whole new underwater world and a whole new type of underwater photography. Let's look at some examples.

Above—This pair of Blue Tang *(Acanthurus coeruleus)*, also known as Surgeon or Doctor Fish, were photographed in Key Largo. Most times, I see them in schools, and this image shows the two shades they can change to and from. I photographed them with my Canon dSLR in Watershot housing and a 60mm macro lens behind a flat port. I was about 3 feet from the fish. I used a single strobe set to TTL mode. The manual exposure was f/6.7, $^1/_{125}$ second, and ISO 100. The white balance was set to auto. Following page, top—I photographed these Reef Squid *(Sepioteuthis sepioidea)* during a trip to Roatan. I shot in the portrait format because the squid were in more of an up/down orientation than a left/right formation. I used my housed Canon dSLR, flat port, and 60mm macro lens. The camera was in manual mode and set to auto white balance. I held the camera so the strobe, used in TTL mode, would light the squid from above. The exposure was f/4.5, $^1/_{90}$ second, and ISO 100. The subjects are reflective, so keeping a distance of roughly 4 feet from them and using my strobe in TTL mode (it discharged at less than full power) helped prevent clipped highlights. In postproduction, I cropped the image but maintained the aspect ratio of the camera sensor, 3:2. Following page, bottom—This macro image was taken during a trip to Roatan. This Redlip Blennie *(Ophioblennius macclurei)* posed for me, and its position made it easy for me to separate it from its surroundings, leaving just blue water in the background. I used my housed Canon dSLR, 60mm macro lens, and a flat port. My strobe was a Sea & Sea YS 110a, set to TTL. Macro lenses produce a shallow depth of field, and what is not in acceptable focus is blurred. This can be a desirable effect, known as bokeh. I positioned myself so the water was in the background and I was about 3 feet from the Blennie. An advantage to macro is that the lens's narrow angle of view allows for a greater working distance from the subject, which means you are less likely to spook it. My exposure was f/5.6, $^1/_{90}$ second, and ISO 100.

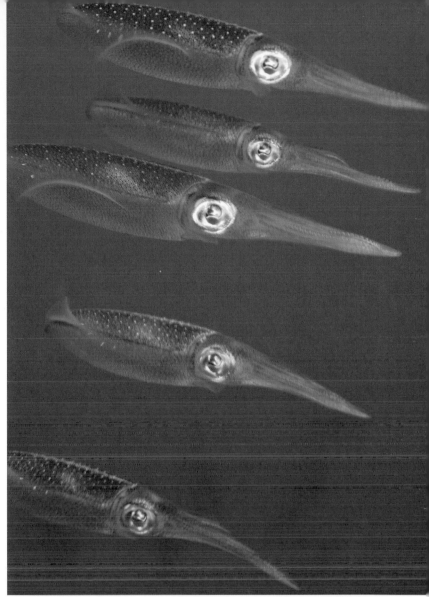

Below—I photographed this Puddingwife Wrasse *(Halichoeres radiatus)* more by accident than by design during a dive in Key Largo, FL. I happened to look to my side and there it was, it the open water. I turned and grabbed the shot while the fish was about 2 feet away from me, though I was on the hunt for much smaller subjects. I used my housed Canon dSLR and a 60mm macro lens with a flat port. I had a single strobe positioned over the top of my port for top-lighting, and the strobe was set to TTL. My manual exposure settings were: f/5.6, $^1/_{125}$ second, and ISO 100. I generally use the auto white balance feature and center-weighted average metering. These settings work in most cases, and with so many other things to take into consideration while shooting underwater, it's nice to have less to worry about. **Following page, top**—On this dive in Roatan I was out seeking subjects the size of my hand to photograph with my 60mm macro lens, and this Green Sea Turtle *(Chelonia mydas)* showed up out of the blue. I'm an opportunist and equal opportunity shooter, so I quickly grabbed a shot. I had my trusty housed Canon dSLR and 60mm macro lens behind a flat port and single strobe in hand. I shoot in manual mode with my starting-point exposure settings dialed in. These setting ensure that, even if I do not get a perfect exposure, it will be close enough to manage in postproduction. I fired away at f/5.6, $^1/_{125}$ second, and ISO 100, at 5 feet or more from the turtle. This is normally at the end of a lens's range if we desire a colorful image. But, I have learned that with a macro lens you can "reach out and touch someone"—in this case, a turtle. In postproduction, I increased the saturatuation of the water and turtle to bring back color lost through absorption due to the camera-to-subject distance. **Following page, bottom**—It is fun to take close-up portraits of marine life. This Spiny Lobster *(Panulirus argus)* was backed into the recesses of the corals, trapped and at my mercy. But I was diving for photographs, not for dinner, and this was a great subject for me. I used a Canon 500D (cropped-sensor camera) in Watershot aluminum housing, a 60mm macro lens, flat port, and a single strobe set to TTL. The TTL strobe setting works best for me for macro work, as shooting at full power often leads to overexposure. I was less than 3 feet from the lobster when I got the shot. The angle of view of my lens allowed me to fill a pleasing percentage of the frame with the subject while remaining far enough from it to avoid scaring it off. My manual exposure settings were pre-set to f/5.6, $^1/_{125}$ second, and ISO 100.

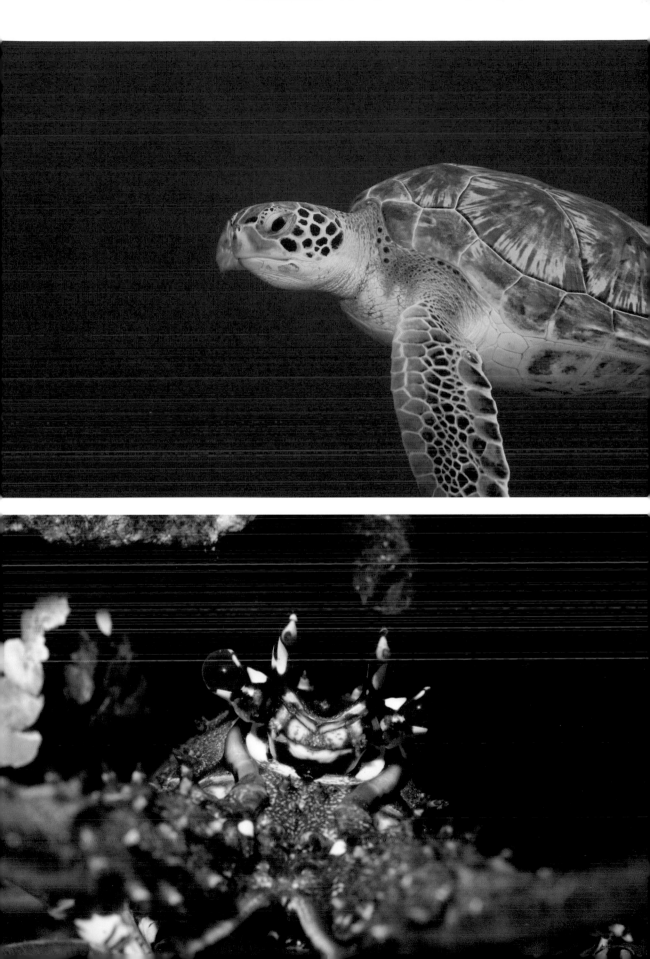

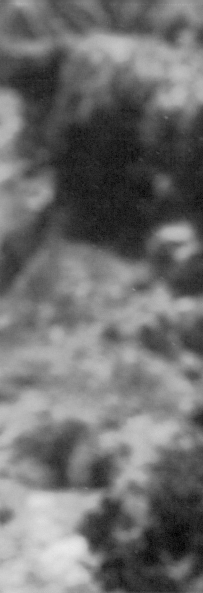
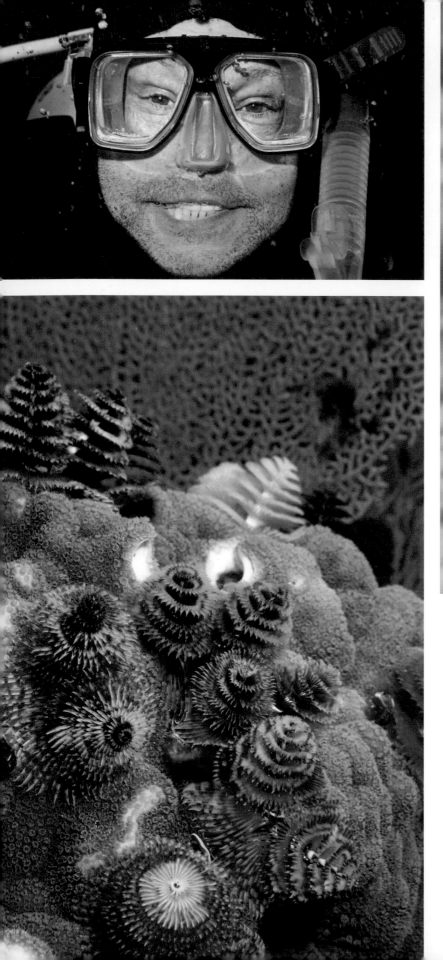

Previous page, top—I used my 60mm macro lens to capture this head shot of a friend. He is a hard-working husband and father of two, and when he comes diving with me he forgets about shaving, which I like because I can, too. I shot at a distance of 3 feet from him with a full-powered, diffused strobe. My exposure settings were f/6.7, $^1/_{125}$ second, and ISO 100. The detail macro lenses produce is spectacular.
Previous page, bottom—These Christmas Tree Worms (Spirobranchus giganteus) were photographed with my housed dSLR and 60mm macro lens from a distance of 1 foot or so. This type of subject is very small; each worm is about half the length of the average thumb. This is what macro photography is about. The very narrow angle of view of a macro lens allows us to better fill the frame when photograph-ing small subjects. My exposure settings were f/11 and $^1/_{125}$ second. Because I used a smaller aperture, I reciprocated by increasing the sensitivity of my sensor; I shot at ISO 200 rather than ISO 100. Above—I took advantage of the extra working distance that a macro lens allows to photograph this Porgy, also known as a Porkfish (Anisotremus virginicus). Most times I see them in small schools. This one came out of the blue, and its motion caught my attention. I grabbed this head-on, eye-to-eye shot using my preset exposure of f/8, $^1/_{90}$ second, and ISO 100. The strobe was used in TTL mode.

Below—Having come from the wide angle school of underwater photography, where I was accustomed to photographing whole fish and big schools of fish, I quite enjoy the macro lens in that it affords me a different style of shooting and allows me to acquire different types of underwater photos of fish—like this "head and shoulders" image of a Snook *(Centropomus undecimalis)*, which was nearly 3 feet in length. I shot with my 60mm macro lens behind my flat port and from a distance of 2 feet. My exposure was f/4.5, $^1/_{125}$ second, and ISO 100. **Following page, top**—This is another instance in which I was able to take advantage of the working distance my 60mm macro lens affords. This Squirrelfish (Holocentrus adscensionis) was content to be where it was, and I was happy to be able to compose and get its photo. Had I tried moving closer, I'm sure I would have caused it to swim off. Fortunately, the angle of view of the lens was narrow enough to allow this small fish (8 inches long) to fill a pleasing portion of the frame. This photo was taken with my dSLR and a single strobe set to TTL. My exposure settings were f/4.5, $^1/_{125}$ second, and ISO 100. Due to the large aperture, my strobe, set to TTL, discharged at less than full power. **Following page, bottom left**—This Flamingo Tongue Snail *(Cyphoma gibbosum)* has a shell-like body and is ornately marked. These are one of the subjects of a macro photographer's dreams. Most times Flamingo Tongues attach themselves to Sea Fans, pictured here, or to Sea Rods. They are small and hard to see, around the size of a pad on your finger. When shooting macro, take a close look into larger subjects like Sea Fans and Sea Rods for the small things living among them. This image was captured with a 60mm macro lens at 1 of distance. The strobe was set at TTL and used for top lighting (see the shadow below my subject). My exposure was f/8, $^1/_{90}$ second, and ISO 100. **Following page, bottom right**—This shot of a Flamingo Tongue *(Cyphoma gibbosum)* was taken from a different vantage point—its side— in order to separate it from its normal background, a Sea Fan. There was 1 foot of working distance between my flat port and the Flamingo Tongue. Reviewing the file properties reveals that I took this photograph with exposure settings of f/5.6, $^1/_{90}$ second, and ISO 100. I used a single strobe set to TTL.

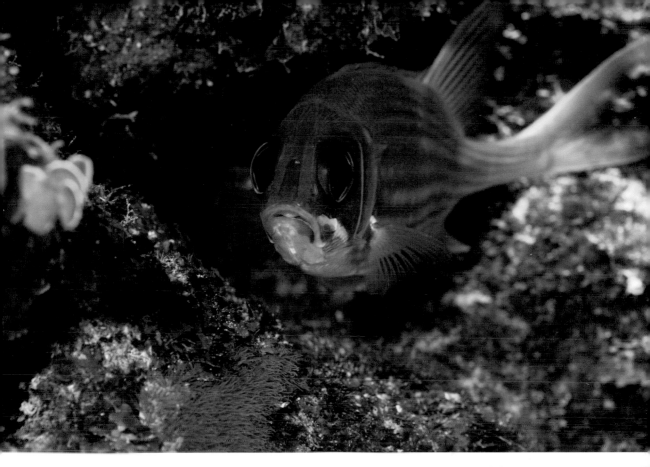

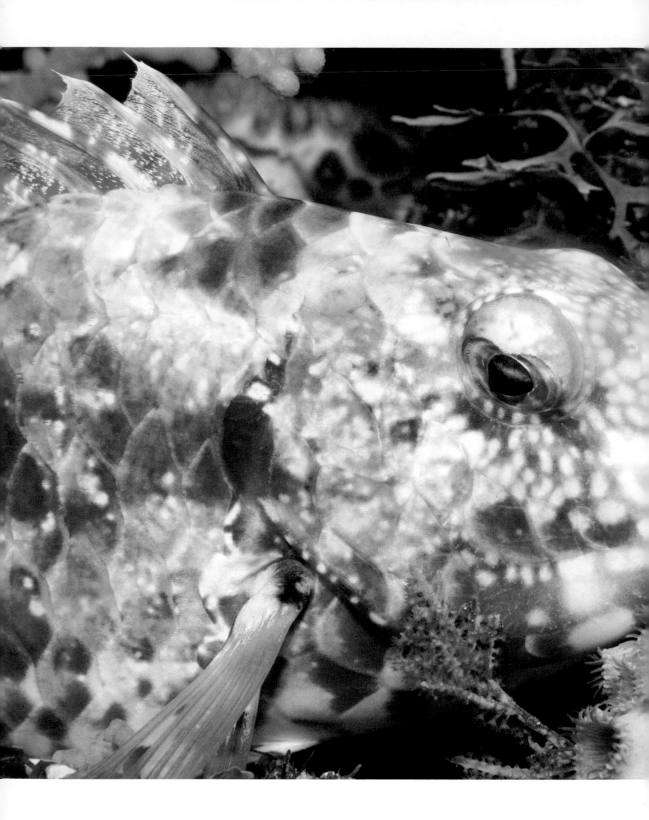

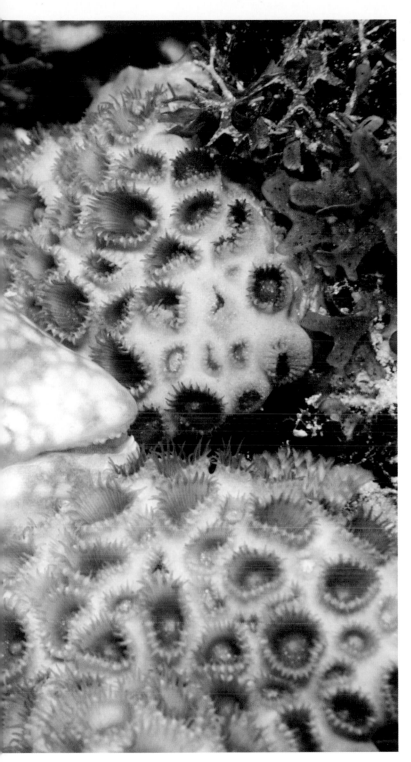

This image was taken on a summer night. I dove with my 60mm macro lens; it was a departure from using a mid-range zoom lens when night diving. When shooting macro at night, it can be tough to acquire focus—especially with a macro lens. There are ways to overcome this challenge: use a dive light, attach a modeling/focus light to your camera, use the modeling/focus light built into your strobe (if it has one) and manually focus. My strobe has a modeling/focus light built in, and that is my preference. At night, I use pretty much the same exposure settings that I use during daytime underwater photography. I just rely on my strobe for most if not all of my light. The moonlight (and starlight, if available) is my only source of ambient light— and it is minimal. My exposure settings for this image were f/11, $1/90$ second, and ISO 200. My strobe was set to TTL.

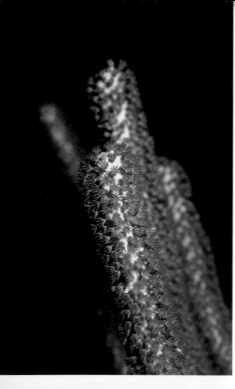

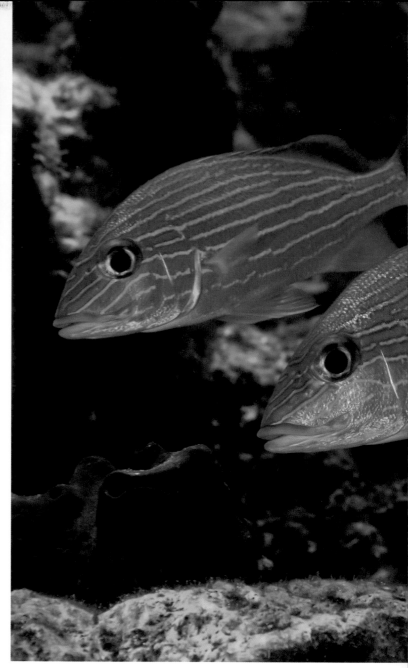

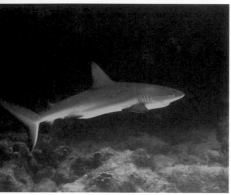

Top left—A macro lens can re-solve individual polyps, as shown in this night photo of Sea Rods filter feeding. Macro lenses have a narrow depth of field, so it is important to carefully focus on the main feature of your subject. You can increase the depth of field by stopping down the lens or increasing your working distance. I took this shot with art rather than scientif-ic documentation in mind. An artful aspect to this image is its near-black background. Also, the sec-ondary subject, the rest of the Sea Rod, is blurred. My manual exposure was f/6.7, $1/_{60}$ second, and ISO 100. The strobe was set to TTL, and I shot from a distance of just under 2 feet. **Bottom left**—Years ago, I was diving with a couple of photographer friends. One was using a housed Nikon D70 with a 60mm macro lens. I was using my wide-angle lens that day. We were diving along the top of a coral ledge that bordered a large sandy area when suddenly an Eagle Ray appeared and swam a good distance away and across the sandy area. It was too far away from me to allow for a photo, but my macro-lens-bear-ing friend took a shot. The image turned out nicely; the subject was in sharp focus and filled a pleasing

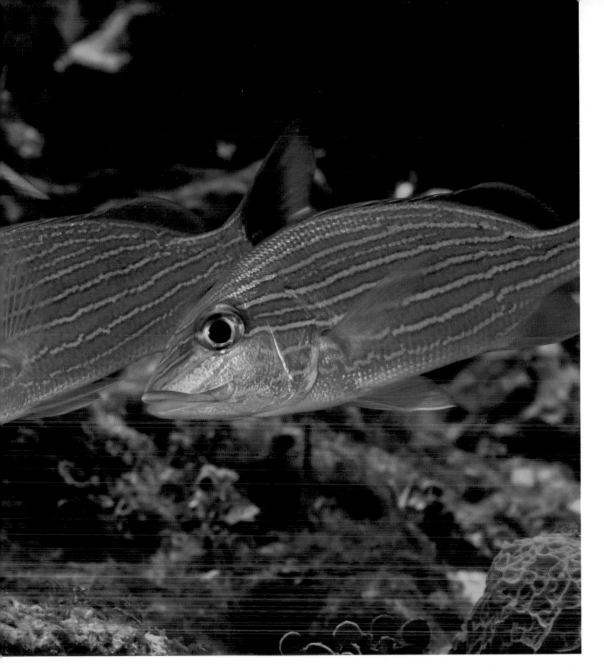

percentage of the frame. Unfortunately, due to the subject's distance and the water's absorption effects, color was diminished. Years later, I took this photo of a Gray Reef Shark *(Cahrcharhinus perezii)*. I was armed with my 60mm macro lens. This scenario was much like the one in which my friend photographed the Eagle Ray, and I got a similar result. Later, I brought the image into Lightroom, increased the contrast, and adjusted the blacks. The image is monochromatic due to the distance, but I was able to grab a shot of a not-often-seen subject. The exposure was f/4.5, $^1/_{125}$ second, and ISO 100. The strobe had no impact due to the distance. **Above**—This macro image was taken at a distance of 3 feet from the three aligned Blue-Striped Grunts *(Haemulon sciurus)*, and they held their position while being photographed. The exposure settings were f/8, $^1/_{125}$ second, and ISO 100. I used a single strobe set to TTL.

Top—This Spotted Drumfish *(Equetus punctatus)* lives on a wreck off-shore of Key Largo. On the day I photographed this fish, I mounted my 60mm macro to my dSLR behind my flat port and did the dive looking to photograph it. The fish, approximately 6 inches in length, fills the frame better with a macro lens than with a wider lens. I used an aperture of f/4.5, a shutter speed of $1/125$ second, and ISO 100 to capture this image. My strobe was positioned over the top of my port. I took the photo from a little more than 3 feet away. **Bottom**—This rather large specimen, an 8- to 10-inch Red Lionfish *(Pterois volitans)*, afforded me a nice opportunity for making a fish portrait with my 60mm macro lens. The exposure was f/4, $1/125$ second, and ISO 100. A single strobe was positioned over the top of my flat port and set to TTL. I shot from a distance of just under 2 feet. **Following page**—Here, three Blue-Striped Grunts *(Haemulon sciurus)* were stacked nicely under a coral ledge. I worked from a distance of about 3 feet, so I would

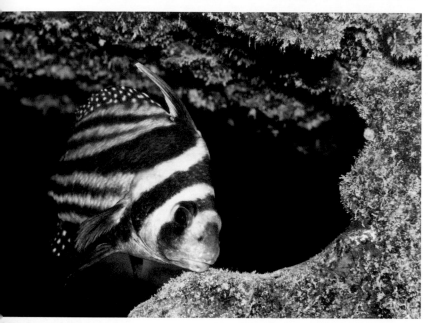

not startle them and cause them to abandon their formation. I framed them in the portrait format, as they were vertically oriented. Even before taking the photo, I could see that I'd have good contrast between their bright-yellow color and the dark background, a hollow in the coral. Composition was foremost in my mind. I wanted to balance the fish with the negative space. I made the exposure at f/8, $1/90$ second, and ISO 100. I used a single strobe in TTL mode, positioned above my flat port and slightly to its right. I did not want too much light in the background.

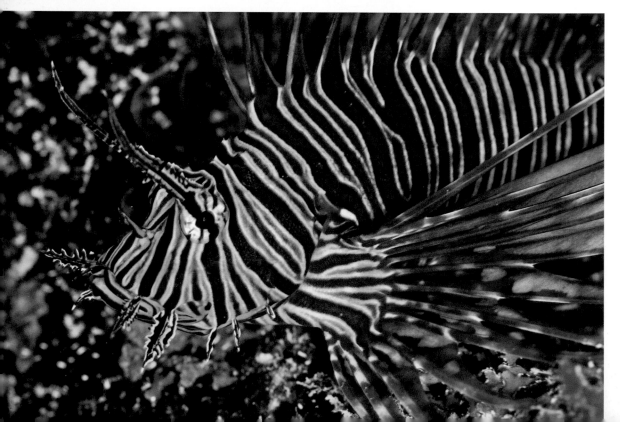

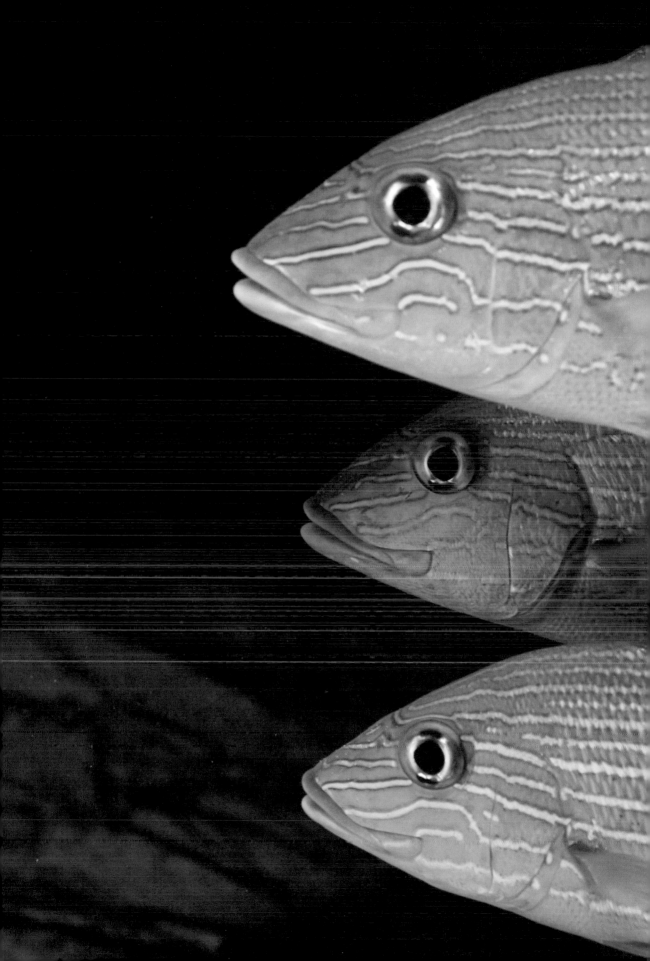

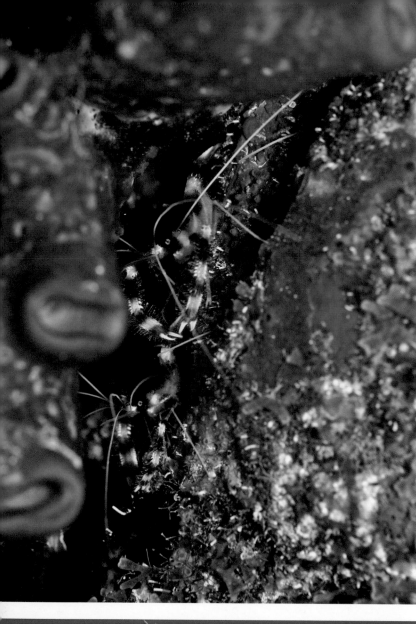

Top—Banded Coral Shrimp *(Stenopus hispidus)* make their living performing cleaning duties for other aquatic life; they remove parasites from them, which they use for food. They are known for setting up shop in a location and staying there for several days. They are small, and this pair was 2 to 3 inches. Because of their size, they are best photographed with a macro lens. I made this exposure manually at f/4.5, $1/125$ second, and ISO 100. I aimed my diffused strobe, set to TTL, directly into the small crevice sheltering the shrimp. Because macro lenses have a shallow depth of field, I focused on one of the shrimp's eyes. Bottom—A macro lens is a great choice for photographing small reef scenes, such as this coral outcropping. Outcroppings of corals have great colors and textures and usually more than one species of coral or other marine life to pique a viewer's interest. They are an easy capture unless you are dealing with current or surge. You can choose good vantage points without concern over damaging nearby coral life. This image was made with my 60mm macro lens behind a flat port. The exposure was f/5.6, $1/125$ second, and ISO 200. My strobe was centered over my port; because I was using a macro lens, I set the strobe to TTL. My distance from the subject was a little over 2 feet. To enhance the image and add impact, I darkened the water in Lightroom.

Top—Susanne Skyrm used her Canon T1i in a Watershot housing with a flat port, a 60mm macro lens, and an Inon S-2000 strobe in TTL mode to capture this photograph of a Sea Horse *(Hippocampus)*. She was diving at the Blue Heron Bridge near West Palm Beach, FL. This is an increasingly popular dive site for macro photographers. Susanne shot in the manual mode. Her exposure settings were f/13, $1/60$ second, and ISO 200. She was approximately 1 foot from the Sea Horse when she took the shot. She writes, "All Sea Horses are shy and want to turn away from the camera/photographer. Finding one is challenging enough, but once found, patience is key." Bottom—Susanne Skyrm captured this Splendid Cozumel Toadfish *(Sanopus splendidus)* in the only place where they are found: Cozumel, Mexico. She used her housed dSLR, 60mm macro lens, and one strobe. Fighting the strong current Cozumel is known for, she got to within 2 feet from her subject and, working in manual mode, made the capture at f/6.7, $1/125$ second, and ISO 100. She used a strobe set to TTL mode.

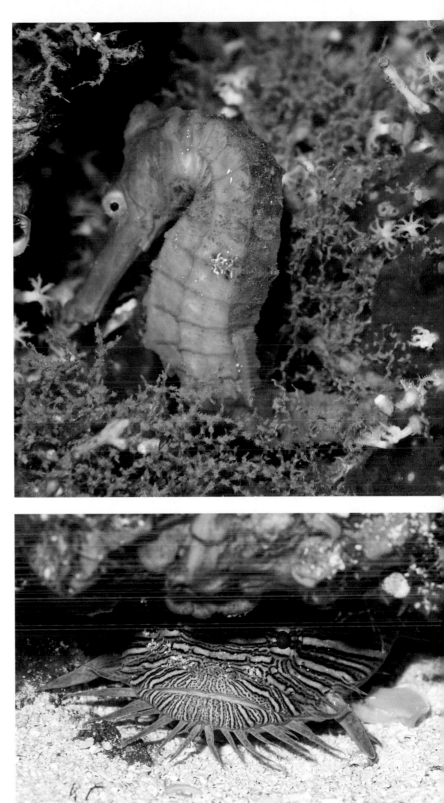

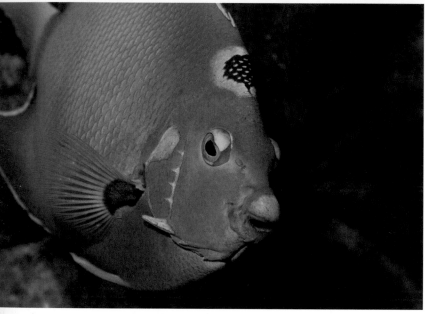

Top—This Blackbar Soldier Fish *(Myripistis jacobus)* photo could only be made with a macro lens. Had I used a lens with a wider angle of view, I would have needed to be closer than 3 feet from the fish to fill the same amount of frame as I did with my 60mm macro lens. In that case, I would have spooked the fish from the recess of the coral it was sheltering in. I exposed this image at f/8, $^1/_{125}$ second, and ISO 100. I used a diffused strobe set to TTL. From this distance, I'm sure the strobe fired at full power. Bottom—The beauty of using a macro lens is evident in this close-up of the ornately marked Queen Angelfish *(Holacanthus ciliaris)*. I focused on the fish's eye as best I could, as the fish was in motion. The shot was made at a distance of $2^1/_2$ feet, with a strobe. The exposure was f/6.7, $^1/_{125}$ second, and ISO 100. Following page—Here is a Slender Filefish *(Monacanthus tuckeri)* nestled in this Sea Rod. I captured a partial black background (there was too much clutter back there to render it all black), plus pleasing bokeh. I was happy with both compositional outcomes. I used my housed dSLR and 60mm macro lens behind my flat port. I also used a diffused strobe set to TTL. My exposure settings were f/5.6, $^1/_{125}$ second, and ISO 100. The glass-to-subject distance was 1 foot.

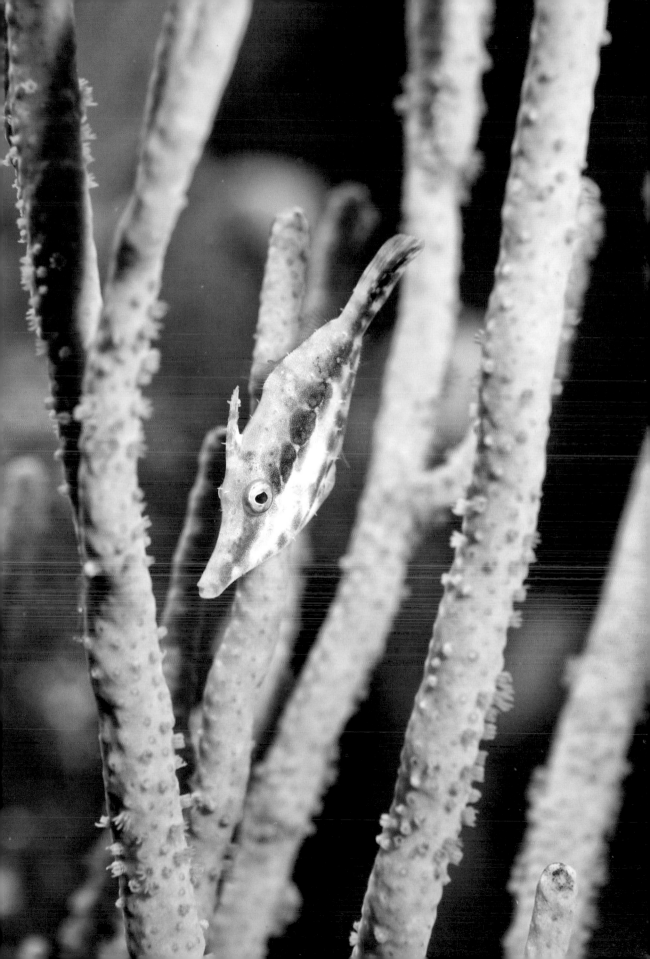

ULTRA-WIDE-ANGLE LENSES

I define an ultra-wide-angle lens, either rectilinear or fisheye, as a lens with a greater than 90-degree angle of view. Some examples are the Canon 10–22mm, Tokina 10–17mm fisheye, Sigma 10–20mm, Nikon 12–24mm, and some prime lenses (such as the Canon 14mm) used on full-frame cameras. PnS camera users can mount wide-angle wet-lenses that yield similar angles of view. Also, Watershot Inc. offers a wet-lens dome that fits over the housing lens port of their smartphone housings; these allow for an ultra-wide angle of view.

To me, ultra-wide-angle lenses are specialized lenses used to photograph large subjects at close distances. In fact, their angle of view is so wide that if you are not close to your subject, it will appear small in your frame—no matter its size—and likely will not lead to a pleasing composition.

Ultra-wide-angle lenses offer a minimum focus distance of 1 foot or less. In most cases, when photographing reef scenes with an ultra-wide-angle lens, my glass-to-subject distance has been inches. At times, I have been fearful that I might damage the coral and my dome port due to working so close. (*Note:* Ultra-wide-angle lenses are used behind dome ports, as vignetting will occur if a flat port is used.)

Let's take a look at some images made with ultra-wide-angle lenses.

Below—A group of divers and I were in Bonaire during the early stages of an island-wide reef restoration project. Small pieces of Staghorn Coral (Acropora "farming" coral) were hung from stands to allow them to filter-feed in shallower waters in sheltered areas. They were moved to the main reef and epoxied to the substrate when they were viable. I used my Canon dSLR in Watershot housing, large dome port, and two strobes to capture this event. My lens was the Sigma 10–20mm, at 10mm. I fired the strobes at $^1/_2$ power given the shallow water and good amount of ambient light. My exposure was f/8, $^1/_{90}$ second, and ISO 100. I was just over 1 foot away from the closest "tree." There is some barrel distortion (i.e., concave bending of straight lines) in the trees. This is a characteristic of wide-angle lenses, and it is particularly prominent when ultra-wide-angle or fisheye lenses are used. Fortunately, few underwater subjects have straight lines. Following page—Susanne Skyrm titled this image *Diver Over the Wall, Cozumel.* She told me she was within $1^1/_2$ feet of the subject, and a sense of serendipity came over her as she witnessed

the diver floating over the wall as she was photographing the Branching Tube Sponges (*Pseudoceratina crassa*). She shot with a Canon T1i in a Watershot housing and a diffused Inon S-2000 strobe at full power. Her Tokina 11–16mm lens was at 15mm behind a 6-inch dome port. Susanne's exposure settings were f/6.7, $^1/_{125}$ second, and ISO 100.

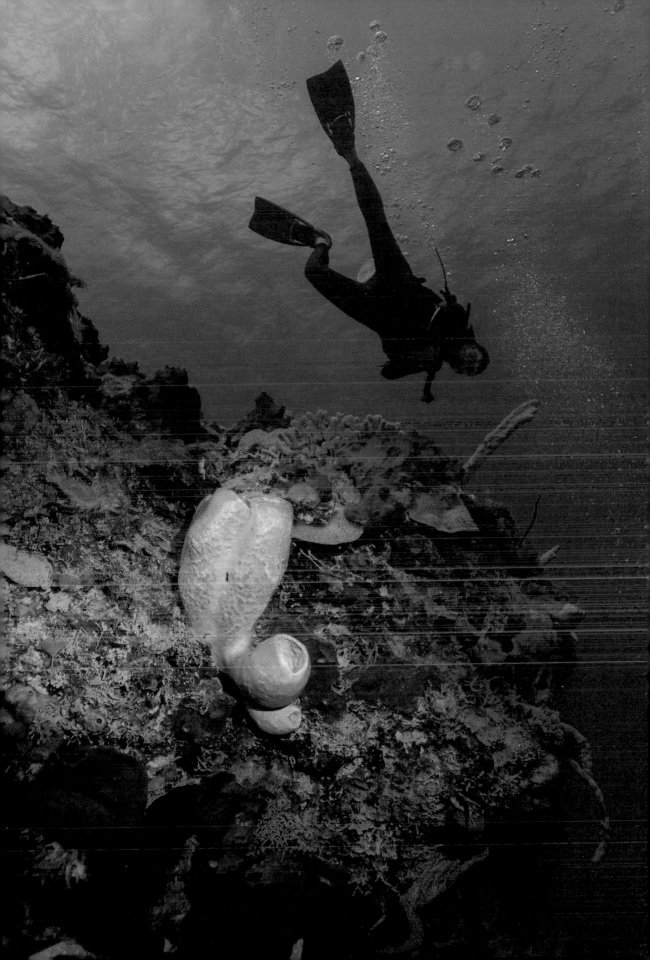

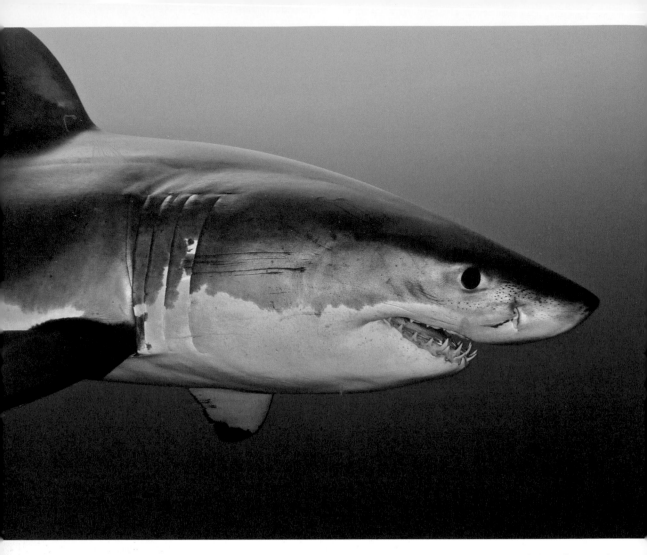

Ultra-wide-angle lenses are an excellent choice for photographing sharks that are being fed or chummed and come in very close to you. Sharks are large, so it is important to choose a lens that covers their size. In this photograph, courtesy of John Shaheen, a Great White Shark *(Carcharodon carcharias)* is pictured passing by a cage John was photographing from. This photo was taken on a trip to Guadalupe Island, Mexico—one of the few places in the world where this type of diving is done. John used his Olympus XZ-1, a wide-angle wet-lens, and two strobes to take this shot. The shark was approximately 3 feet away. Sharks are two-toned. You usually light the top part of the shark with your left-side strobe and use your right-side strobe, at a lower output setting, to add a bit of fill light for its underside. In this instance, John had both strobes set to TTL (automatic). He used an exposure of f/7.1, $^1/_{125}$ second (in instances when sharks are moving faster, a faster shutter speed is often used), and ISO 100.

Top left—This image falls into the "What was I thinking?" category! I used a housed dSLR and Tokina 10–17mm fisheye lens to create this image. With this lens, if I am not close, my subject will appear miniscule. The lens was new to me, and I used my large dome port and the shortest port extender I had. The extender needed to be shorter because, when set to 10mm, its widest angle of view, I ended up with vignetteing. A vignette can occur when any lens's angle of view is wider than what is allowed through any port, extended or not, and with any type of camera in an underwater housing. It can be overcome by changing the extender/port combination or zooming in, if using a zoom lens, to slightly narrow the angle of view. Top right—Here, I waited until my dive buddy got closer to take an image. She fills a more pleasing percentage of the frame. Her closer proximity allowed me to eliminate at least half of the detritus in the water column for my strobes to illuminate. I used the same camera, lens, port, and exposure settings as in the previous photograph. I cropped the vignette out in postproduction. Bottom—Of the three photos in this series, this is the keeper. The exposure settings were the same for all three photographs. I used two strobes, both diffused and at full power, to cover the extreme wide angle of view of the Tokina 10–17mm FE lens. My manual exposure was f/5.6, $^1/_{125}$ second, and ISO 100. I zoomed in a bit, to 13mm, to eliminate the vignette. My distance from the subject was just under 1 foot.

Above—An ultra-wide-angle lens is an excellent choice for photographing large groups of divers. A variable zoom lens like the Sigma 10–20mm will do the job at either end of its focal length range; the wide angle of view will allow you to easily capture the whole scene. In this instance, I was at a distance of 3 feet from the front of the group. The limiting factor in this pose is that the far diver was just over 5 feet away and beyond the reach of the strobe. At that distance, the reds were absorbed by the water. I used my strobes at full power and removed the diffusers, knowing I'd need all the power I could get. My aperture was set to f/4.5. (Opening my aperture up from my normal starting point aperture of f/5.6 allowed me to gather a little more light; as this was a posed photo, I had time to make exposure adjustments.) I used a shutter speed of $^1/_{125}$ second. I could have used a slower speed, but opted instead to change my ISO from 100 to 200. When shooting groups of divers, you need much more light than you require under normal conditions. Following page—I photographed this Santa Claus sized Sea Rod (Eunicea) on the edge of a wall in Bonaire. I was looking for large subjects on that dive and had my Sigma 10–20mm lens mounted to my housed dSLR behind a small dome port and short extender. A Sea Rod is taller than wide, so I composed in the vertical/portrait format. I used two diffused strobes, both set to full power. I shot at a slightly upward angle to include the surface, and the wide angle of view (focal length at 10mm) enabled me to also capture the reef in the foreground. My shooting distance was just less than 1 foot, and I filled a pleasing percentage of the frame with my subject. My manual mode exposure was f/6.7, $^1/_{125}$ second, and ISO 100.

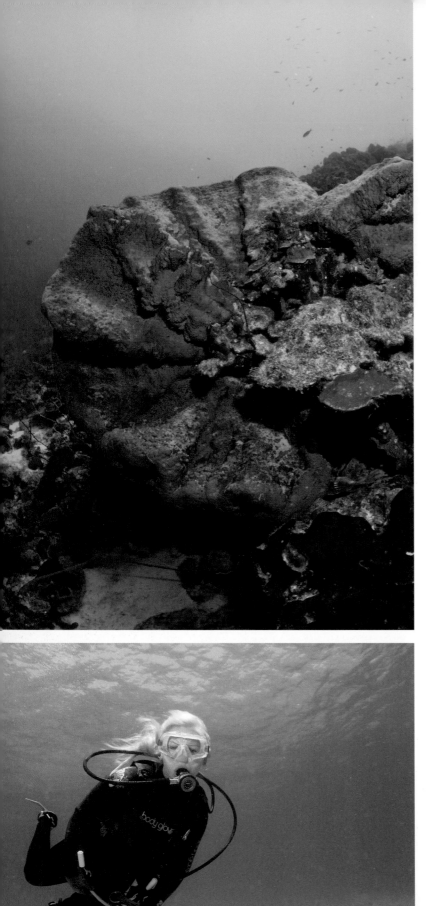

Top—I've loved the colors found on the coral reefs for over fifty years, and my ultra-wide-angle lens allows me to capture large, colorful chunks of a reef scene, such as this giant Orange Elephant Ear sponge *(Agelas clathrodes)*. I photographed it in the portrait format as it made a nicer composition and from its side so I could use the water column for separation and negative space. In my opinion, reef scenes are all about composition. Here, the blue and orange colors complement each other and enhance the composition. My manual exposure settings were f/6.7, $^1/_{125}$ second, and ISO 100. My lens was set at its widest focal length, 10mm. I was 1 foot from the sponge and fired my strobe at full power. **Bottom**—I took this posed shot for a friend who opened a dive center in Jacksonville, FL, and needed some imagery for his website and brochures. I used my full-featured Olympus SP 350 in its OEM housing and my Sea & Sea YS-120 Duo strobe. I attached my wide-angle wet-lens to capture Kelly's whole figure. With the 100 degree angle of view of the wet-lens, I was able to let her approach to a distance of 2 feet before I took the shot. I set the strobe to half power given the close shooting distance. My exposure was f/8, $^1/_{100}$ second, and ISO 100. I had good luck with the colors with the white balance set to auto. **Following page**—This gathering of Branching Tube sponge *(Pseudoceratina crassa)* protruded from the wall, making it easy for me to separate it from its surroundings. I worked my way into a vantage point where I could include the drop-off of the wall in my scene, then framed in the portrait format and eased left to get the water column in the background. My lens was set at 10mm, and I needed to be close to fill the frame with these sponges, which I shot from 1 foot away. My manual exposure settings were f/5.6, $^1/_{125}$ second, and ISO 100. I had two diffused strobes mounted and set to full power.

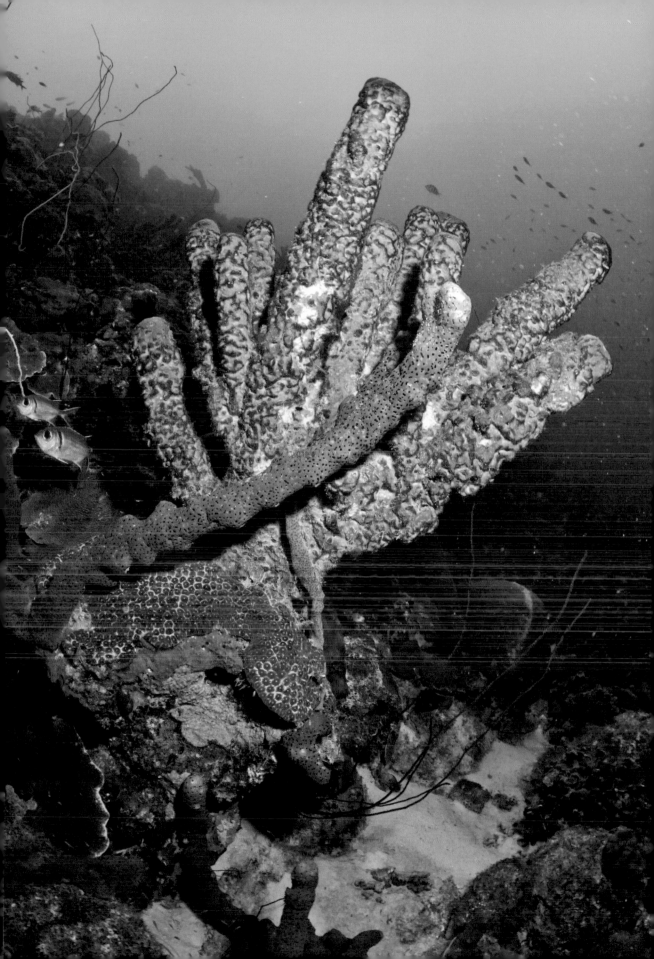

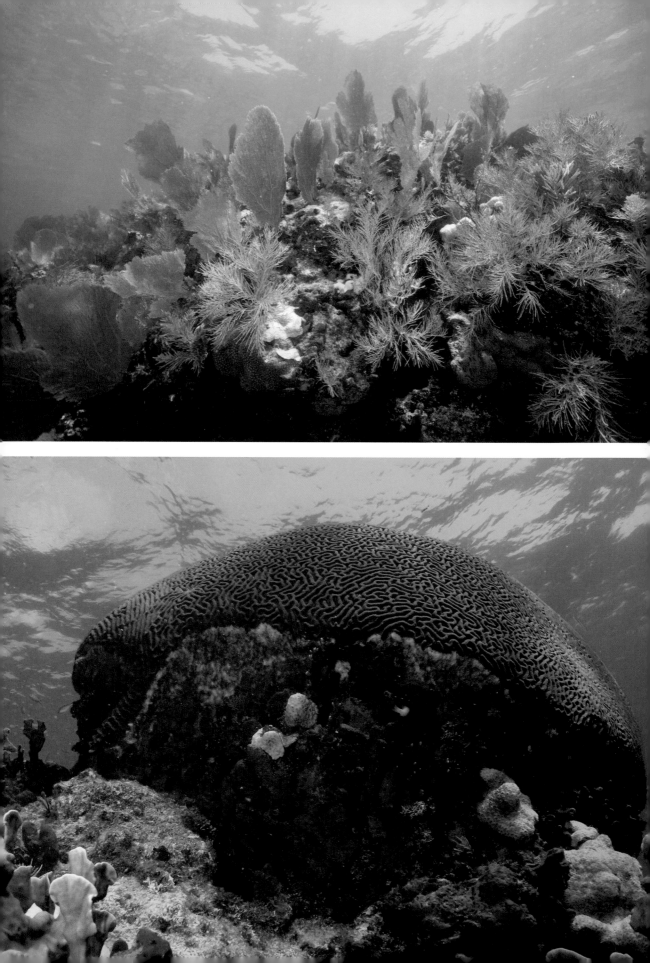

Previous page, top—For this photo of a whole reef, I used my Sigma 10–20mm lens at a focal length of 10mm. I also used two strobes. When I use one strobe, it is always mounted on the left-hand side. That way, I can use my right hand to operate my shutter control and my left hand to aim the strobe. Using one strobe might have worked in this scenario, but the right side of the scene would have been a little darker than the left side, so I used a second strobe to add light on the right side for more more balanced lighting. I decided to fill approximately $^2/_3$ of the frame with reef and included the water column in the scene for negative space and its color, which was a nice complement to the colors in the corals. This scene was approximately 10 feet across. My working distance was just under 1 foot. My lens was behind my large dome port. My strobes, a Sea & Sea YS 110a (left side) and an Inon S-2000 (right side) were diffused, set to full power, and aimed straight ahead. My manual exposure settings were f/8, $^1/_{125}$ second, and ISO 100. Previous page, bottom—This is one of the largest heads of Brain Coral *(Diplnia strigosa)* along the reef in the upper Florida Keys waters. It is at least 10–12 feet across and easily 8–9 feet in height. It is definitely a subject for an ultra-wide-angle lens. Without it, one's working distance would have to be so great that colors would be absorbed by the water between the strobe and subject. I took this shot from a distance of nearly 5 feet—the outer limits at which color is maintained. I used my full-featured Olympus SP 350 PnS camera and mounted an Inon wide-angle wet-lens and my Sea & Sea YS-120 Duo strobe. I removed the strobe's diffuser as, when a diffuser is used, one gives up 1 f/stop's worth of strobe power. I knew I would need the strobe's full power output at my working distance. I exposed manually at f/8, $^1/_{100}$ second, and ISO 100. The Brain Coral rests in 25 feet of water. Had I been much deeper, I would have had to use a wider aperture, a slower shutter speed, or a higher ISO. Below—Elkhorn Coral *(Acropora prolifera)* are a fast-growing coral but are susceptible to environmental changes and, as such, large stands of it are increasingly hard to come by. This fact makes it a worthy subject. Because of its size, it is best photographed with an ultra-wide-angle lens. My distance from this coral was minimal. When I took the photo and looked up over the top of my camera, I feared I might bump the coral with my large dome port. I was that close. This would have caused damage to both the coral and dome port. The coral is more important to protect than the dome. My exposure settings were f/8, $^1/_{125}$ second, and ISO 200. My variable zoom ultra-wide-angle lens, a Sigma 10–20mm, was set to 10mm. I used one strobe and centered it above my system. It is necessary to use two strobes when shooting with this lens, especially at 10mm.

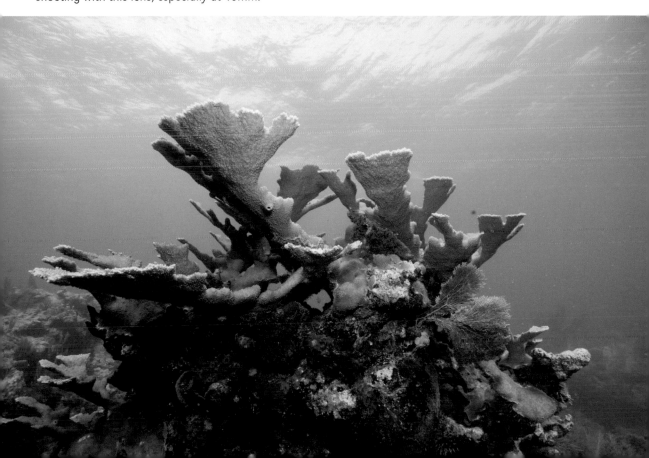

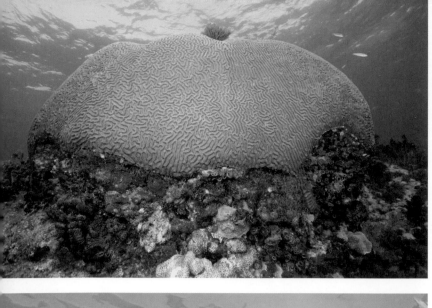

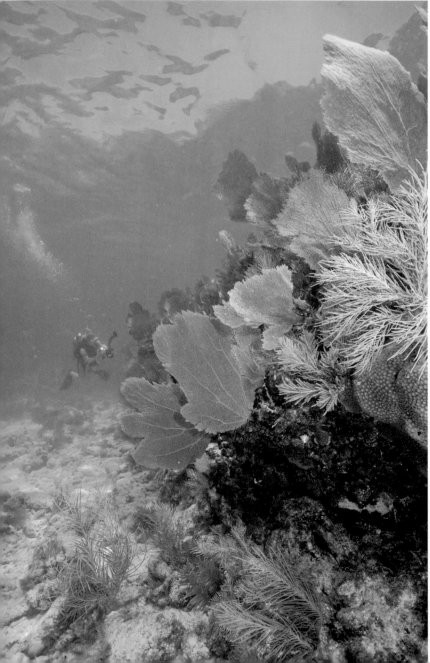

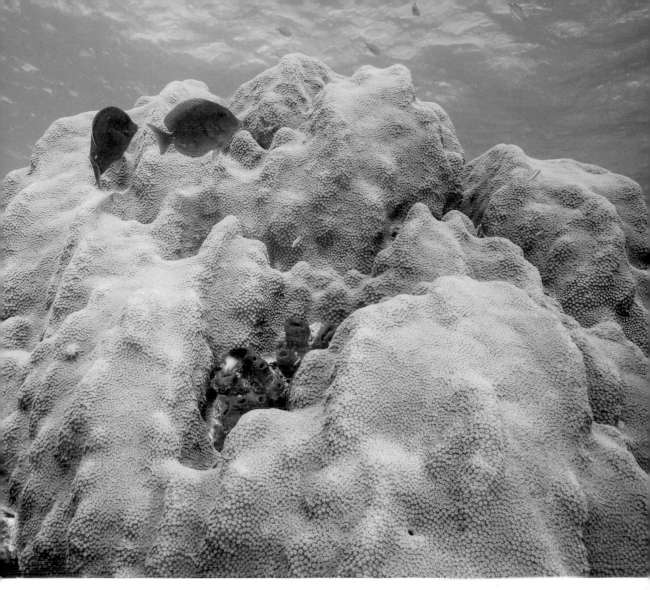

Previous page, top—This image of the largest head of Brain Coral *(Diplonia strigosa)* in the upper Florida Keys was taken using my dSLR and 10–20mm lens behind my large dome port. Given the size of the subject, an ultra-wide-angle lens is the best choice, and two strobes light the subject more evenly across its width. My distance was less than 2 feet. The exposure was f/6.7, $^1/_{125}$ second, and ISO 100. Both strobes were set to full power and aimed straight ahead. Previous page, bottom—Here, my primary subject was a coral scene in the foreground, and my secondary subject was my photo-dive buddy in the background. The image was taken in clear, shallow (less than 30 feet) water on a sunny day. Ambitious compositions like this one suit an ultra-wide-angle lens just fine. I shot in the portrait format, with one strobe below and one strobe above my housing. I used the lower strobe to illuminate the coral scene and I turned the upper strobe straight up, which is a quick and handy way to not employ it. Alternatively, a person could simply turn it off and back on again later. I composed the scene to include both subjects in the frame and allowed water to add some negative space. With the strobe at full power, my manual exposure was f/6.7, $^1/_{125}$ second, and ISO 100. I was a bit over 1 foot from the coral. Above—Star Coral formations *(Montastraea faveolata)* are mountainous in the coral reef environment. This Star coral was serving as a fish cleaning station, and these two Blue Tangs *(Acanthurus coeruleus)* were trying to use its facility. However, when I appeared, all but one of the several Yellow Cleaner Wrasse working the station headed for cover. I was diving this day with my housed dSLR, large dome port, and my 10–20mm ultra-wide-angle lens. I had two diffused strobes mounted and used both at full power. Had I only been using one strobe, on my left side, the right side of the Star Coral would have been insufficiently lit. I was looking for large subjects to photograph. This works. My exposure settings were f/5.6, $^1/_{125}$ second, and ISO 100. I zoomed in halfway from 10mm to 15mm to help give these hand-sized Blue Tangs some heft in the frame.

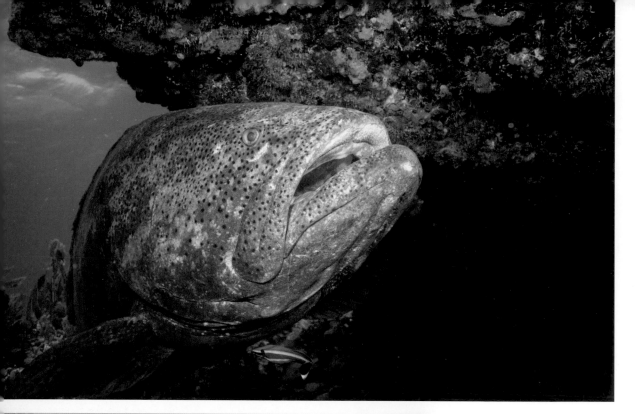

Top—The Goliath Grouper *(Epinephelus itajara)* is the largest in the family of groupers and a rightfully protected species. I photographed this 8-foot-long specimen in the waters of the Key Largo National Marine Sanctuary and at Molasses Reef. A subject of this size is perfect for an ultra-wide-angle lens. This grouper sees lots of divers; because of its size it is not wary of us and can be approached if you move slowly. I was able to get my large dome within inches of its face. I zoomed in to 20mm on my 10–20mm ultra-wide-angle lens. I made the exposure at f/6.7, $^1/_{125}$ second, and ISO 100.

I used two diffused strobes at full power. The grouper was under a ledge and in deep shadow. Using two strobes helped me bring out the colors of the coral and sponge growth on the ledge. Bottom—Star Coral *(Montastraea faveolata)* is the mountain-building coral on the coral reef. Here, an assembly of Star Coral "boulders" had formed on top of the limestone substrate. For a subject of this size—they stretch at least 10 feet across—an ultra-wide-angle lens is needed. I used two strobes, diffused and at full power, to light both ends. I shot with my Watershot-housed Canon dSLR and my Sigma 10–20mm lens at 10mm behind my large dome port. I made the shot from just under 2 feet. My exposure settings were f/8, $^1/_{100}$ second, and ISO 100. Following page—This scene of a Sea Rod *(Plexaurella homomalla)* growth and small stand of Elkhorn Coral *(Acropora prolifera)* caught my eye, so I went for it. My distance from the near subject, the Sea Rod, was 1 foot. My two strobes were at full power and diffused to spare me from "burning" the Sea Rod with too much light. My exposure settings were f/5.6, $^1/_{125}$ second, and ISO 100.

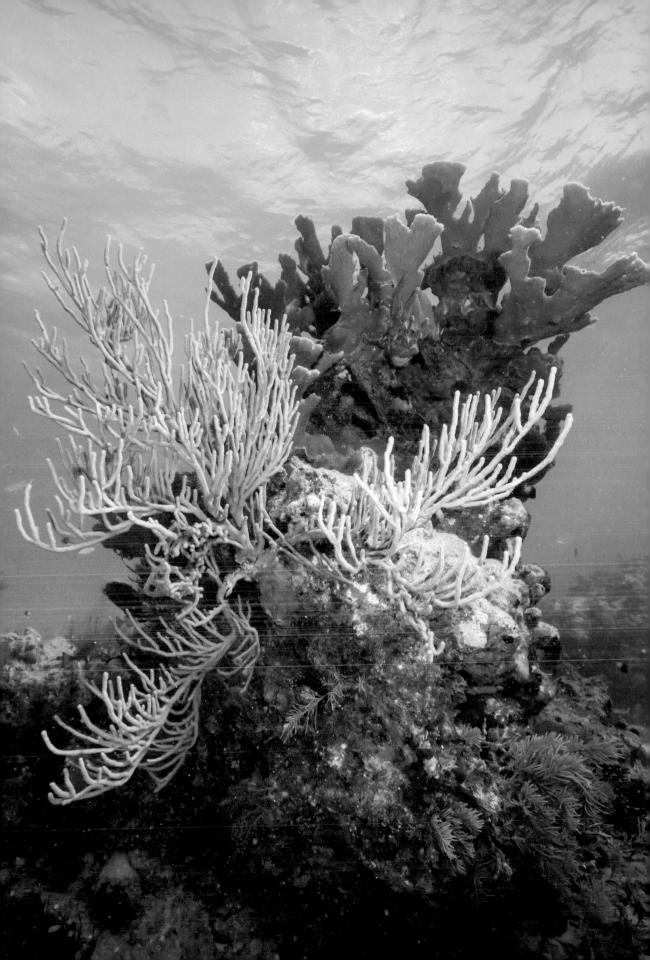

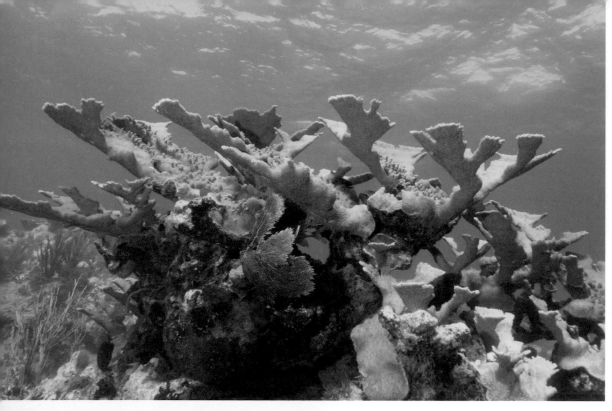

Top—This large stand of Elk Horn Coral *(Acropora prolifera)* is ideal for the ultra-wide-angle lens and this type of photography. The ultra-wide-angle lens, whether a prime lens or variable focal length lens, requires large-sized subjects. Due to its angle of view, small subjects will appear tiny in the final image, unless the photo is cropped in postproduction. For this image, I used my Canon dSLR and a dome port. My 10–20mm lens was set at 10mm. I used two strobes at full power to evenly light both sides of the coral. I was almost dome-to-edge-of-coral in distance. I was in less than 20 feet of water, so I could get away with using an aperture of f/8. My other manual exposure settings were $^1/_{125}$ second and ISO 200 (due to shooting at f/8). Bottom—If you are one of the million divers a year who dive in Key Largo and on Molasses Reef, you will likely recognize this site, known as "The Hole in the Wall." It is a famous swim-thru and popular place to take photos. During this dive, I captured Kelly, my dive buddy and model, pausing to look at the Snappers lingering near the ceiling of the structure. I used my housed dSLR and 10–20mm lens behind my dome port and employed two strobes. Kelly knows that I like to get captures of a diver doing something other than posing for the camera, so she looked at the Snapper in a way that enabled me to capture some of her face and one of her eyes. The right side of the structure was much closer than the rest of the scene, so I backed away my right-hand strobe as far as possible. The left strobe lit most of the remaining area at full power. The exposure was made 3 feet from Kelly at f/8, $^1/_{100}$ second, and ISO 100.

Top—The widest of the ultra-wide-angle lenses is the fisheye, with its 180 degree angle of view. I use a Tokina 10–17mm FE on my cropped-sensor Canon dSLR. Tokina makes this lens with a Nikon mount also. Photographer Steve Philbrook grabbed this shot of a Manta Ray *(Manta birostris)*. When I asked him to tell me about the shot, he said "I rarely shoot in program mode, but as our boat was flying through the channel, we came across this Manta at the surface. I grabbed my camera, threw it into program mode (that way I knew I had a decent chance of getting the exposure close), then jumped in and took the shot as it swam off quickly." The image was taken in Palau in the German Channel. Steve used a Canon T2i in a Nauticam NA-550D housing and a Tokina 10–17mm fisheye lens at 10mm behind a 4.33-inch mini dome. The image was made with ambient light. Bottom—While I own and use both lenses, I prefer rectilinear lenses to fisheye lenses because fisheye lenses produce more barrel distortion (as illustrated in Steve's image) than do wide-angle rectilinear lenses. Barrel distortion is the concave curving of straight

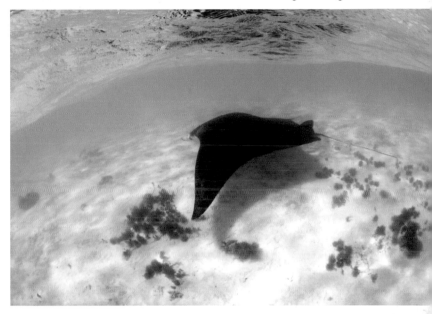

lines in an image. It is most noticeable when straight lines are located along the edges of the frame. The fisheye lens has a very close focus—inches or less—so it has advantages in addition to its extreme wide-angle view. Also, there are not many straight lines underwater to distort. For these reasons, fisheye lenses made for both full-frame and cropped-sensor cameras have become very popular among underwater photographers over the recent years. This image was made in program mode. The exposure was f/8, $^1/_{160}$ second, and ISO 100.

THE 100MM MACRO LENS

The 100mm macro is a lens made for 35mm film cameras and dSLRs with full-sized, 24x36mm, sensors. The 60mm lens, on the other hand, was developed for use with cropped-sensor dSLRs. While most underwater photographers who dive with cropped-sensor cameras use a 60mm macro lens, it is possible to use the 100mm macro lens. In fact, it is often my lens of choice for my DX camera.

One advantage to the 100mm macro lens, especially when used on a cropped-sensor dSLR, is its magnification. We can work from a greater distance and still fill a pleasing percentage of the frame with the subject. A greater working distance can keep us from spooking our subjects—but remember that for good color, the maximum working distance is 5 feet.

On a full-frame dSLR, the 100mm lens's angle of view is 24 degrees; on a cropped-sensor camera, it is even narrower. To get the whole subject in the frame, the working distance must be increased. This is not a bad thing. Also, this lens produces a shallow depth of field, but working from a greater distance allows for more depth of field.

The depth of field you can expect varies markedly from one focal length to the next. At f/8 and 3 feet of working distance, a10mm focal length yields a depth of field from 1 foot to infinity; an 18mm focal length gives a depth of field of over 3 feet, roughly split on either side of the 3-foot focused distance; a 60mm lens affords about 3 inches of depth of field, bordering both sides of the focused distance. The depth of field of the 100mm lens is less than 1 inch!

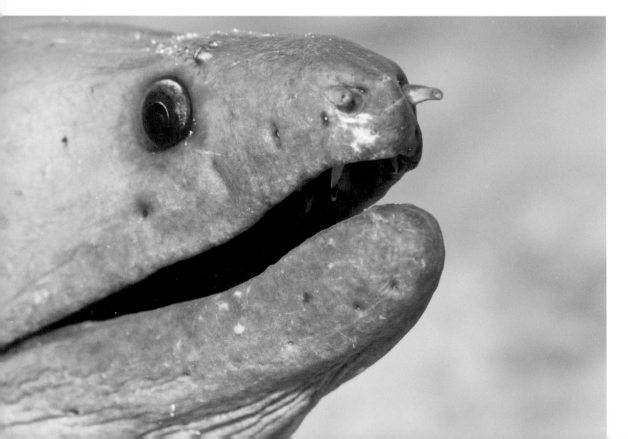

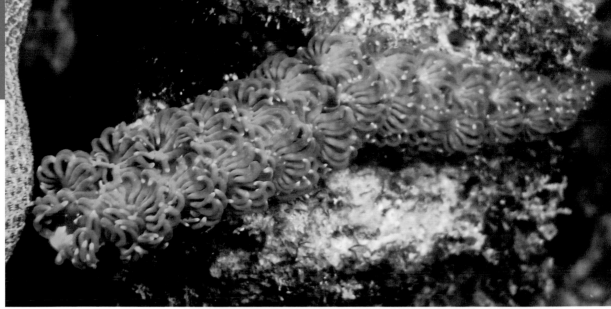

Previous page—I photographed this Green Moray Eel *(Gymnothorax funebris)* using my flat port and 100mm macro; it is ideal for "fish-face" photography. There are two features to this subject: its teeth and eyes. It's best to focus on one or the other. The exposure was f/6.7, $^1/_{125}$ second, and ISO 100. I used a single, diffused strobe in TTL mode. My working distance was just over 2 feet. **Above**—Hector Sequin, Jr. photographed this Blue Dragon Sea Slug *(Tridachia crispata)* with his Sea Life DC 1000 in macro mode. He used the camera's built-in flash and shot from 4 inches, the camera's minimum focusing distance. The exposure was f/3.5, $^1/_{60}$ second, and ISO 200. **Right**—The 100mm macro lens is a great tool for creating an artful image of coral polyps. This Sea Rod's *(Eunicea spp.,* a Gorgonian) polyps were out and filter feeding. There was nothing but water in the background, so there was nothing to distract from the subject. The exposure was f/11, $^1/_{125}$ second, and ISO 100. I was a little over $1^1/_2$ feet away when I took this photograph.

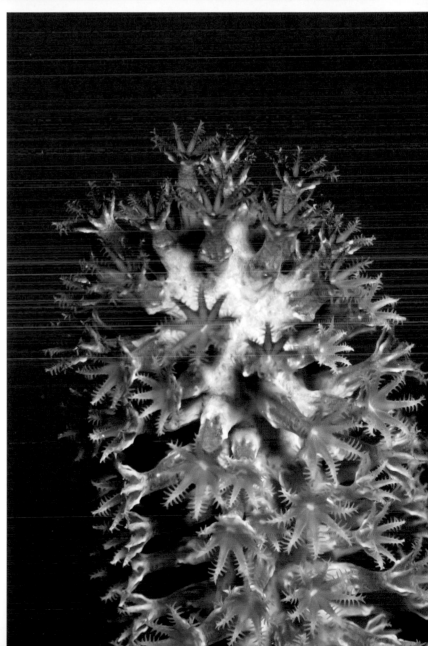

Top—The 100mm macro is a nice lens for creative work. Here, I created an abstract by photographing only a portion of a Cactus Coral *(Mycetophyllia ferox)*. My exposure settings were f/11, $^1/_{125}$ second, and ISO 100. I top-lit the subject using one diffused strobe set at TTL. I was a little over 2 away. **Bottom left**—Here's another look at the 100mm macro lens's ability to resolve detail in coral polyps. These are Corky Sea Fingers *(Briareum asbestinum)*. I made this exposure using a single diffused strobe set to TTL.

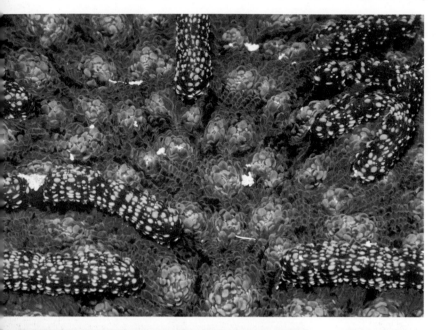

My aperture was f/11, I used a shutter speed of $^1/_{200}$ second, and my ISO was 100. The focused distance was just over $1^1/_2$ feet. **Bottom right**—One of my favorite subjects for color and texture are these Azure Vase Sponges *(Callyspongia plicifera)*. This was a small one, and it was thin-walled near its top. It is usually one color, but my strobe's light penetrated the back inside of the upper wall and somehow created another color! The exposure was f/5.6, $^1/_{125}$ second, and ISO 100. I lit the subject with one diffused strobe, set to TTL, from my upper-left side and from a distance of just under 2 feet.

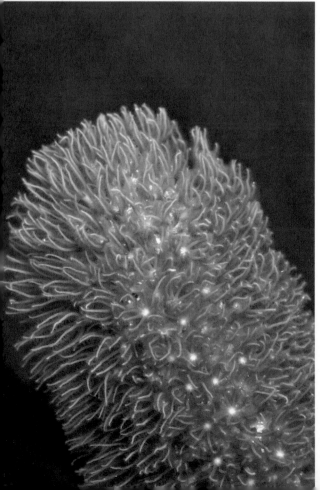

Top—This Great Barracuda *(Sphyraena barracuda)* held its mouth open for a cleaning by a neon Goby Cleaner Fish. The 100mm macro captured a nice "fish-face" shot for me. This Barracuda was 3 feet long—too big to be captured by a 100mm macro with its narrow angle of view. The exposure was f/8, $^1/_{125}$ second, and ISO 100. My strobe was set to TTL and I worked from a distance of just over 3 feet. The Barracuda is a very reflective fish; I used the strobe at less than full power so as to not wash out the fish. Bottom left—Sergeant Majors *(Abudefduf saxatilis)* are members of the Damselfish family. They fiercely protect eggs laid by their mates, giving us the opportunity to make photographic captures. I made this photo at f/5.6, $^1/_{125}$ second, and 100 ISO. I used one diffused strobe set to TTL to top light my subject. I focused from 1 meter. Bottom right—This was an earlier photo of the same Sergeant Major. They dart to and from their nest to chase off predators, including other Sergeant Majors, who want to prey upon the eggs they guard. The exposure was f/5.6, $^1/_{125}$ second, and ISO 100. I used one strobe, on TTL, with a diffuser. The distance was 1 meter. This photo is a good example of the very narrow angle of view of the 100mm macro lens. The fish is the size of an average person's hand.

Top—The macro lens, whether 100mm or 60mm, is a fun lens to shoot for creative, outside-the-box applications. Here, I created an abstract of Brain Coral *(Colpophyllia natans)*. I made this image using exposure settings of f/11, $^1/_{125}$ second, and ISO 100. I used one strobe and, to avoid shadowing, top-lit the subject. I did not want my focus to fall off, so used a small aperture for a wider depth of field. A convention in photography, topside or underwater, is to set your shutter speed near to or at the focal length of your lens or faster to avoid blur from camera shake. When working with a 100mm macro lens, one would use $^1/_{100}$ second or greater for a shutter speed. Bottom—This Four-Eyed Butterfly Fish *(Chaetodon capistratus)* was dancing from one small coral head to another in a feeding frenzy. It would pounce and bite the top of the coral, then retreat a foot or so and repeat. In the meantime, I got set and waited for the decisive moment. My exposure settings were f/5.6, $^1/_{125}$ second, and ISO 100. I used just one strobe. I was working from a distance of $2^1/_2$ feet. Had I been using a wider lens, I'd have had to work much closer to fill the frame and would have risked scaring the subject away.

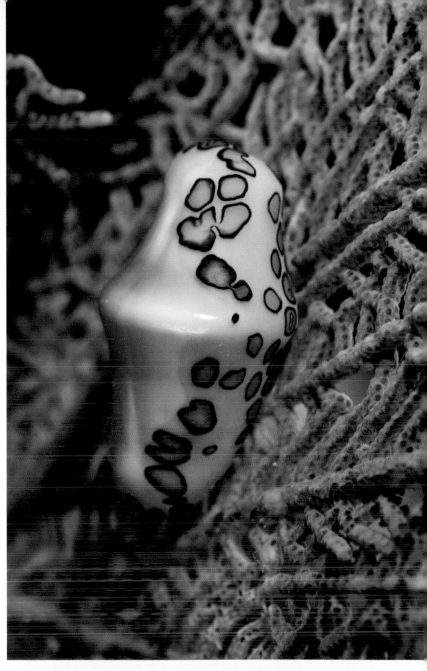

Top—The 100mm macro lens, with its narrow angle of view, is an excellent option for photographing Flamingo Tongues *(Cyphoma gibbosum)*. A Flamingo Tongue, a snail with its skeleton, shell-like, on its exterior, rarely grows larger than the first pad on an average person's little finger. They are very delicate and ornate and look as if they are made of porcelain. I almost always use a single strobe, set to TTL, when shooting macro, and that was the case here. I opted to shoot from the side and managed to get a little negative space (water) in my composition. My exposure was f/5.6, $^1/_{90}$ second, and ISO 100. My working distance was a little more than 2 feet. **Bottom**—This Spiny Lobster *(Panulirus argus)* is too large a subject to be captured using a 100mm macro lens, due to the lens's narrow angle of view. This is an outside-of-the-box type of photograph. I focused on the lobster's eye, framed the shot so the eye would be in the center of frame, and built the rest of the composition around that focal point. I made the exposure at f/6.7, $^1/_{125}$ second, and ISO 100. I used a single diffused strobe, set to TTL, to top-light the lobster. My working distance was a few inches over 2 feet.

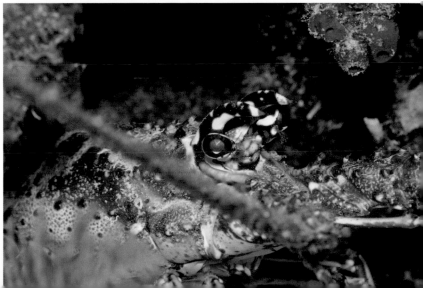

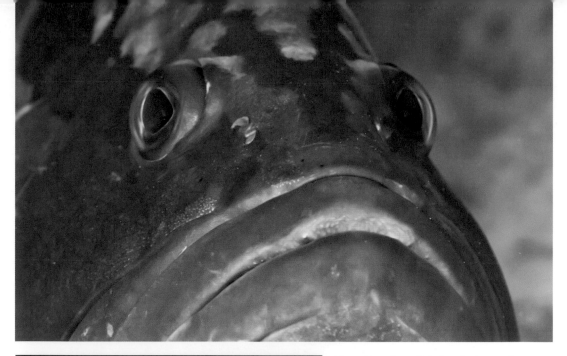

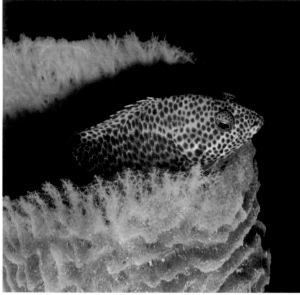

Top—Here is a "fish-face" photo of a good-sized Red Grouper *(Epinephelus morio)*. This one had a travel companion, a Green Moray Eel. They often pair up to hunt. The eel can slither into coral recesses and scare out a fish, and the grouper will chase it and eat it; if part of the prey falls away, the eel will eat that part. The team had broken up when I first got a photo of the eel. Later, the grouper became curious and swam over to me. I turned and suddenly was face-to-face with the fish. I quickly took the chance to grab what I could of the grouper with my 100mm macro lens. I made the exposure manually at f/8, $^1/_{90}$ second, and ISO 100 with a single strobe mounted. The image was recorded from a distance of 2$^1/_2$ feet. **Bottom**—Denise Owen captured this image of a Graysby *(Cephalopholis cruentatus)* perched on the upper edge of a barrel sponge. She managed to produce the black background by using a small aperture of f/11, a fast shutter speed of $^1/_{200}$ second (the shutter speed governs the exposure of the water column; faster = darker), and an ISO of 100. Her working distance was just under 3 feet. She used a single diffused strobe. **Following page**—Using a macro lens enabled me to photograph the Christmas Tree Worm *(Spirobranchus giganteus)* without including distracting elements in my composition. A very large Christmas Tree Worm is smaller than an average person's thumb, so the narrow angle of view of my macro lens afforded me the ability to nearly fill my frame with this subject and made it appear larger than life. I used a 100mm macro lens on a cropped-sensor camera, so the magnification was greater than 1:1. I exposed the image at f/8, $^1/_{125}$ second, and ISO 100. I used a diffused strobe in TTL mode, from 2$^1/_2$ feet away, to add top lighting.

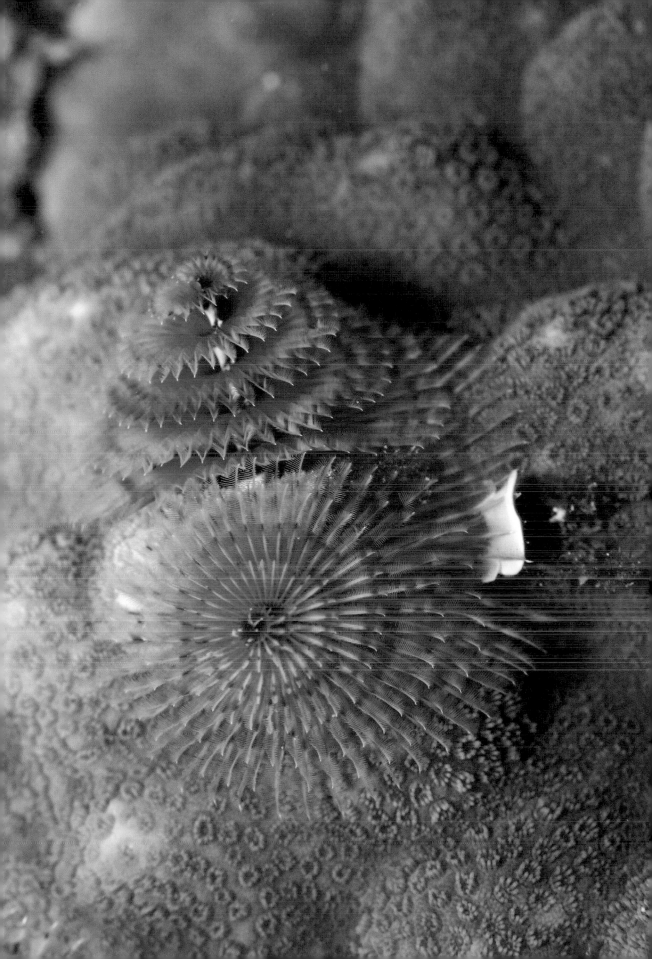

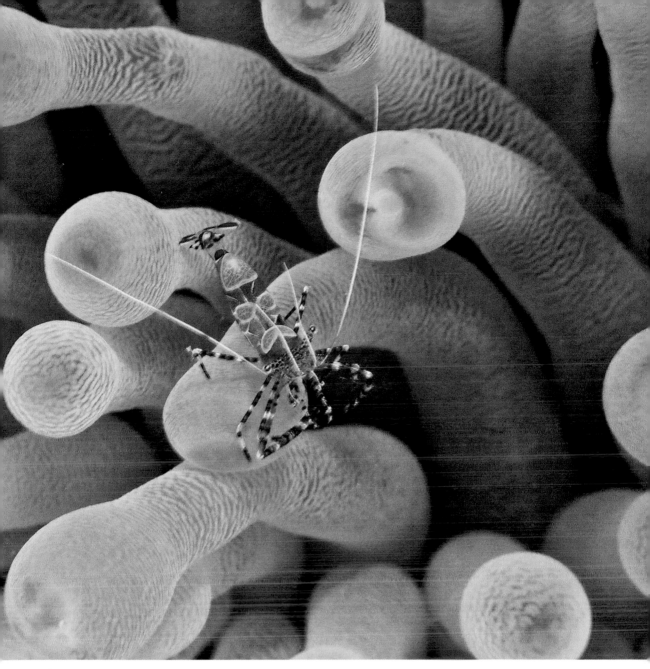

Previous page, top—These mating Flamingo Tongues *(Cyphoma gibbosum)* were photographed on a Purple Sea Fan *(Gorgonia ventalina)*. This behavior is not commonly witnessed. Fortunately, I had a macro lens mounted to my camera; Flamingo Tongues are ideal subjects for macro photography. I shot in the portrait format using a single diffused strobe at its TTL setting, positioned above my camera's left side, so my strobe light came from above. I exposed at f/8, $^{1}/_{90}$ second, and ISO 100. Previous page, bottom—A Trumpetfish *(Aulostomus maculatus)* is not your typical macro subject. On this dive, I used my housed dSLR and a macro lens. I was on a quest to photograph very small subjects which, at the time, eluded me. So I took a chance at photographing the Trumpetfish. I knew I would not get the whole fish in my frame—it is too long—and that I would get either its mouth or eye in my composition. I opted for the eye, and that was my focus point. The fish was horizontally positioned in the water column, and I framed on the diagonal. I had one diffused strobe mounted on my tray and set to TTL. My exposure was f/6.7, $^{1}/_{125}$ second, and ISO 100. I was just under 2 feet away from the subject. Above—John Shaheen captured this image of a Spotted Cleaner Shrimp *(Periclimenes spp.)* in an anemone. The exposure, made in aperture priority mode, was f/7.1, $^{1}/_{100}$ second, and ISO 200. John's camera, an Olympus XZ-1, used in a Nauticam housing, has a variable zoom lens with a 35mm film camera equivalent of 28–112mm focal lengths. He worked his way close, then zoomed to 112mm. John used a Sea & Sea strobe, diffused and set to TTL.

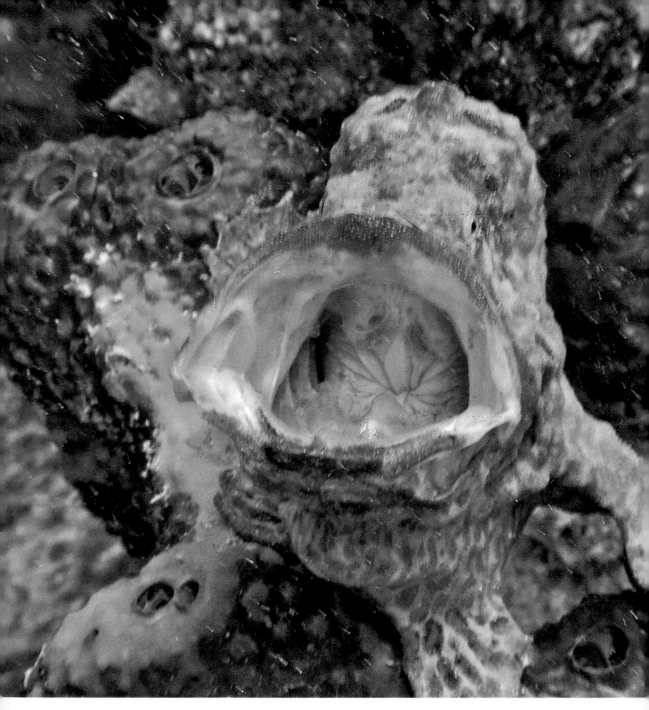

Above—John Shaheen photographed this Frogfish *(Antennariidae)*, which appears to be yawning. This is a good subject for two reasons: (1) Frogfish are uncommon and (2) John captured a behavior. Fish usually do not exhibit normal behaviors when confronted by photographers; they flee. This photo was taken using a Nauticam-housed Olympus XZ-1 camera and an Inon wet-lens adaptor. John prefers to shoot in aperture priority mode, as choosing the aperture gives him control over the depth of field. For this photograph, he set his aperture to f/7.1. Then camera made the other exposure settings automatically. In this case, they were $1/50$ second for shutter speed and an ISO of 200. John used only one of his two strobes and illuminated his subject from above.

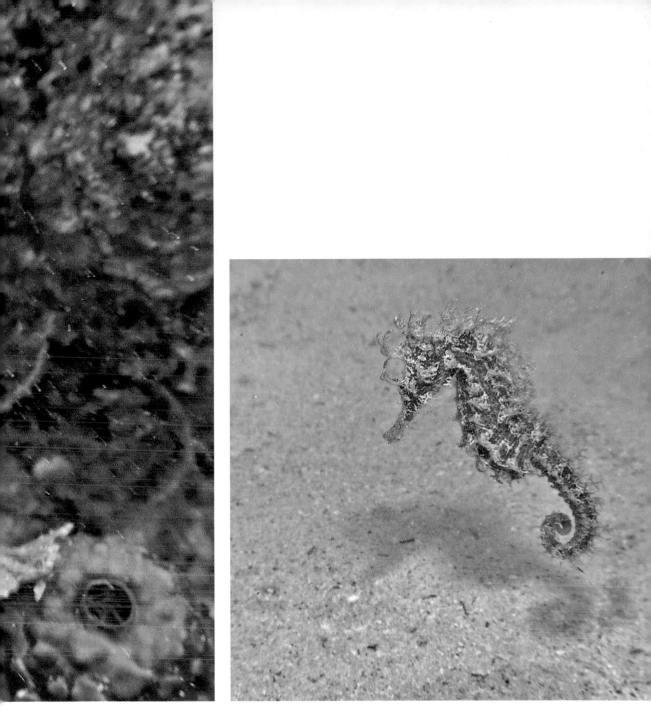

Right—It is a photographer's great fortune to get a capture of a Sea Horse *(Hippocampus)* completely separated from its surroundings. They are most often found wrapped around and obscured by things like Turtle Grass or stalks of hard corals. John Shaheen made this shot happen using his Olympus XZ-1 camera system with the lens zoomed somewhere near the middle of its 28–112mm range. He used the articulation of the strobe arms to move his single, diffused strobe over the center of his system to light this frame. John took the photo with his camera set on aperture priority mode and chose a setting of f/4.5. The camera selected a shutter speed of $^1/_{1000}$ second and and ISO of 100.

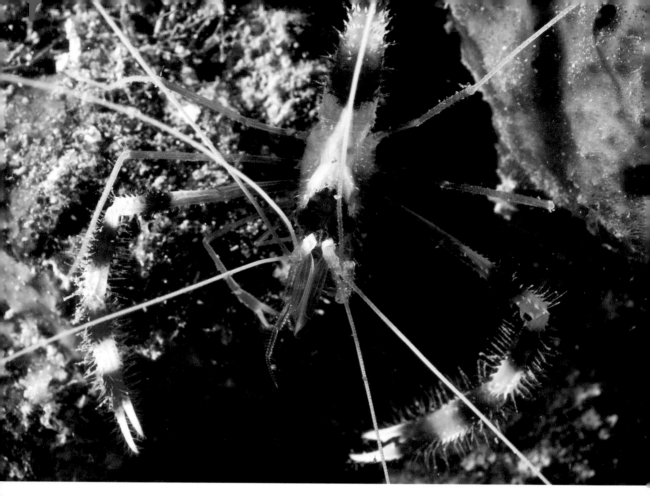

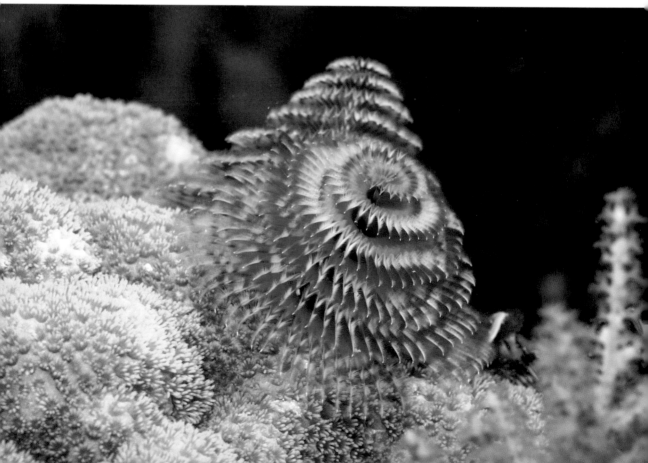

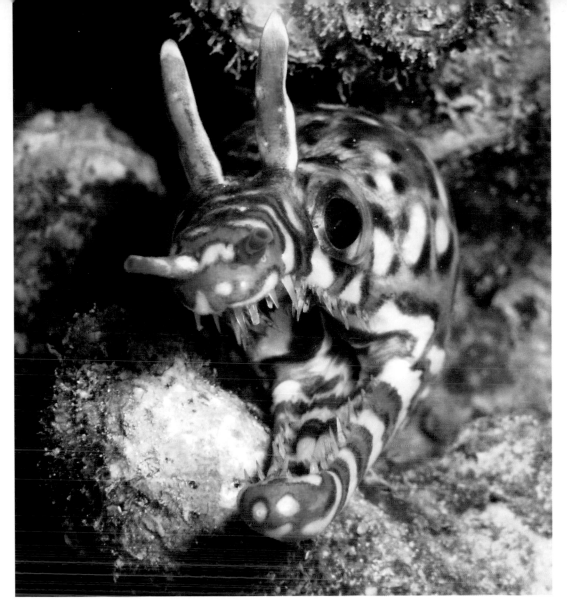

Previous page, top—Dive travel is a key to our growth in underwater photography. Susanne Skyrm made this photo of a Banded Coral Shrimp *(Stenopus hispidus)* while on a night dive under the Frederickted pier in St. Croix. This site is a hot spot for macro-sized subjects and it is shallow enough to afford her nearly 2 hours of bottom time. Susanne shot with her housed Canon dSLR and macro lens behind a flat port. She used a single strobe set to TTL and shot from a distance of 1 foot. Her exposure settings were f/13, $^1/_{200}$ second, and ISO 100. Previous page, bottom—This approximately $1^1/_2$-inch tall Christmas Tree Worm *(Spirobranchus giganteus)* stands out as an example of the subject size that is ideal for macro photography. A lens with a wider angle of view would capture much more of the surroundings, and the subject would fill a small percentage of the frame. This image shows the very shallow depth of field a macro lens yields. I shot with my housed dSLR, with the lens behind a flat port, and used a single strobe, set to TTL. TTL technology has advanced a great deal since its inception in underwater photography in the early 1990s and is reliable. Unless I am trying to be creative with my lighting, I use TTL habitually when shooting macro. My exposure settings were f/11, $^1/_{200}$ second, and ISO 200. I was just over 1 foot away from my subject when I took its photo. Above—Hector Sequin, Jr. photographed this Dragon Eel *(Enchelycore pardalis)* with a Sea Life DC 1000 PnS camera and its built-in flash. The camera has a macro setting which enables it to focus to 4 inches, and Hector took advantage of that feature to make this capture. The DC 1000 selected an exposure of f/6.3, $^1/_{100}$ second, and ISO 64. The camera has a variable focal length lens with a 35mm equivalent focal range of 34–170mm. This shot was made at the longer end of the lens's range, while Hector was approximately 1 foot from the eel.

FRESHWATER ENVIRONMENTS

In the United States, most divers learn or take part of their diving courses in lakes, quarries, and other inland bodies of fresh water and continue to do much of their diving in these environments. It follows that many who later take up underwater photography also do much of their underwater photography in fresh bodies of water. This is what I did. Freshwater underwater photographs taken in some on-shore or near-shore waters, such as lagoons, canals, and marinas, pose challenges that differ from those we encounter in a saltwater coral reef environment. Among these challenges are less colorful subjects, reduced visibility, more turbid water, and less ambient light.

Left—Photographers shooting in freshwater environments encounter less-colorful subjects, reduced visibility, more turbid water, and less ambient light. Following page, top—This photo of a cannon from a Spanish galleon was taken at Jules Undersea Habitat (a.k.a, the Emerald Lagoon) in Key Largo, FL. The lagoon has a soft, silt-covered bottom, and the turbulence of a fin-kick will stir silt up and into your photo. I shot this cannon (pun intended!) from a distance of 2 feet using my Olympus SP350 full-featured PnS camera and a wide-angle wet-lens. I used a single diffused strobe at $\frac{1}{2}$ power. Using the least-possible amount of light helps but does not eliminate backscatter when the

water is clouded with detritus. My exposure was f/4, $^1/_{80}$ second, and ISO 100. **Center**—This shopping cart photograph was taken in a canal waterway in the Florida Keys. When photographing in these waters, try to avoid shooting during the algae bloom, as the bloom reduces water clarity and its particulate matter in the water column can cause backscatter. This image was taken using a full-featured Olympus SP350 set to f/4.5, $^1/_{100}$ second, and ISO 100. I used a single diffused strobe at $^1/_2$ power. **Bottom**—Wreck diving can be done in freshwater. Steve Philbrook captured this image of the Prins Wilem in Lake Michigan using a Canon T2i in a Nauticam housing with a small dome port in front of his Tokina 10–17mm FE lens. His exposure was f/8, $^1/_{125}$ second, and ISO 400, and his focal length was 10mm. (*Note:* Steve used a relatively narrow aperture to allow for greater depth of field and compensated for the loss of light by choosing an ISO of 400.) To light the scene, Steve used two diffused Inon Z-240 strobes. Including a diver in the image allows viewers to get a sense of scale and adds color to the image. Steve shot from just under 2 feet of the diver. The ultra-wide angle of view of the lens enabled him to capture a good portion of the wreck, as well as the full body of the diver.

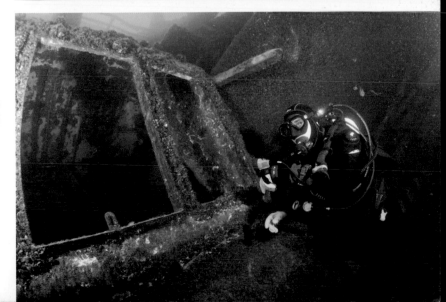

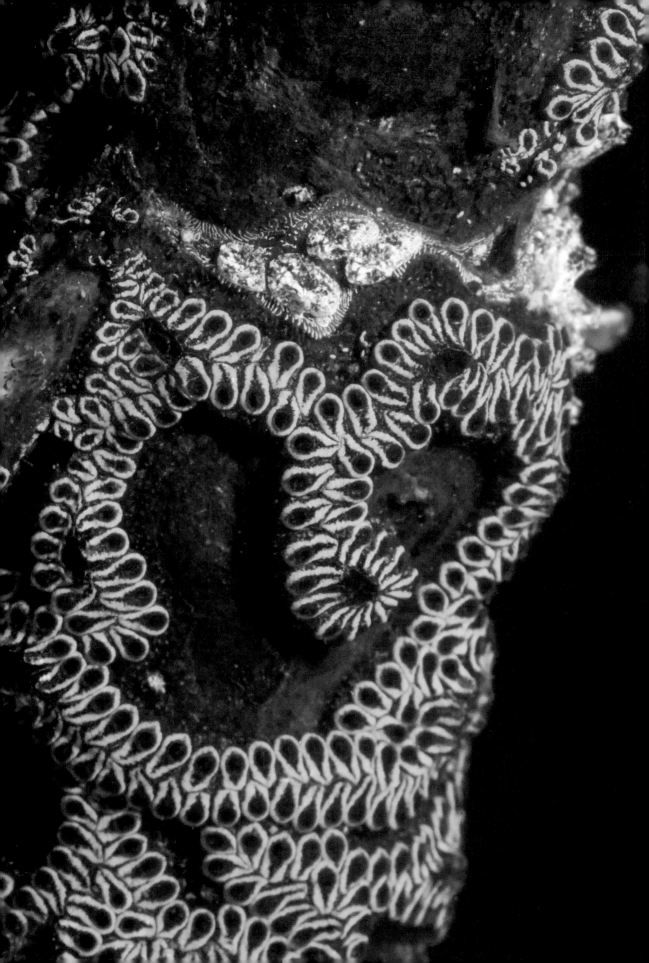

Previous page—Susanne Skyrm purchased a Canon EF 100mm f/2.8L Macro IS lens just before a dive trip to Key Largo, but she got "weathered out" and ended up doing her dives at the Emerald Lagoon located inland in Key Largo. One option when working in low-visibility, high-turbidity water is to do macro photography. This was Susanne's choice, as she wanted to try out her new lens. She ported it behind an extended flat port and mounted it to her Canon T1i in a Watershot housing. She set her Inon S-2000 strobe to TTL. Her shooting distance was just over 1 foot from the subject. The exposure was f/19, $1/_{60}$ second, and ISO 400. She took several shots and adjusted her exposure settings between each. She showed this image to friends, and none of us had seen the subject before or knew its name. Finally, the specimin was identified as a *Botylloides nigrum* (or "the yellow thing"—her name for it—it is much easier to pronounce!).

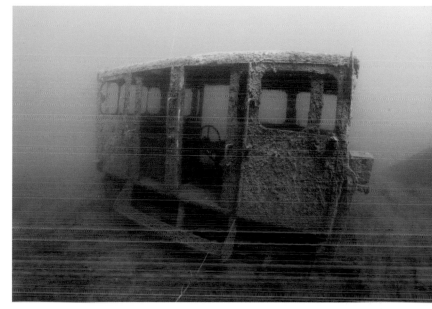

Top—My personal collection of freshwater photographs no longer exists, so I called on two contributors who shoot in that enviroment to help me illustrate this section. In this case, Susanne Skyrm defeated some of the backscatter-causing turbidity by not using her strobe and relying on ambient light to make her exposure. She captured this Large Mouth Bass *(Micropterus salmoides)* and two Blue Gills *(Lepomis macrochirus)* in shallow water from a distance of 3 feet using her housed dSLR and 18–55mm lens zoomed in to 33mm. Her exposure was f/6.7, $1/_{180}$ second, and ISO 200. This photo was taken in summertime at West Silent Lake, Dent, MN. Bottom—In this photograph by Steve Philbrook, a trolley rests on the bottom of Lake Ore-Be-Gone, near Cuyuna, MN. Steve used ambient light only as the wreck was in shallow enough water. He shot with a Canon T1i in Watershot housing and Tokina's 10–17mm FE lens mounted behind a small dome port. His exposure settings were f/8, $1/_{125}$ second, and a higher-than-usual ISO of 400, as he did not use a strobe. He set the camera's white balance to auto.

Susanne Skyrm captured this image of a Blue Gill *(Lepomis macrochirus)* in a defensive posture in a small lake in the upper Midwest. The fish was guarding its nest. The photo was taken using one diffused strobe set to TTL, coupled to a housed dSLR with a variable mid-range zoom lens zoomed to 40mm. The exposure settings were f/9, $^1/_{90}$ second, and ISO 200.

Top—The freshwater diving community often adds subjects to dive on and photograph by sinking things where there was not much to see naturally. Such was the case in this photograph of a sunken jeep, courtesy of Steve Philbrook. Steve also teaches underwater photography, so I will let him explain his approcach to taking the photo: "Filter photography is fun and an inexpensive way to get better color out of your images. It's great for scenic or wreck images since strobes cannot light those large subjects efficiently. This image was taken in the evening when the light rays were dancing off the jeep. What makes the image for me is how the light rays meet and highlight the steering wheel. This image was taken at Lake Ore-Be-Gone in Gilbert, MN." Steve used his Canon T2i in Nauticam NA-550 housing and Tokina 10–17mm fisheye lens at 11mm in ambient light, through a green water Magic Filter. He used a custom white balance. His exposure settings were f/8, $^1/_{125}$ second, and ISO 200. Bottom—Steve Philbrook captured this Large Mouth Bass *(Micropterus salmoides)* image in late May while the bass were spawning. Steve writes: "It's easiest to photograph Large Mouth Bass then because they are easy to approach and will pose while guarding their nest." This image was taken in Cuyuna, MN. Steve used a Canon 70D dSLR in Nauticam NA-70D housing and a Sigma 17–70mm lens behind a large 8.5-inch dome port. He used two Inon Z-240 strobes. His exposure was f/9, $^1/_{100}$ second, and ISO 640. He set the exposure compensation to -$^1/_3$.

Below—Steve Philbrook has done far more underwater photography than I have. He has been shooting longer than I have and has shot more recenlty, too. He says, "Shooting in freshwater has its challenges compared to saltwater, where the water is generally clear. Where I shoot in freshwater, the visibility ranges from 8 to 20 feet on average. To get good, clear images, proper strobe techniques must be used. Angle your strobe(s) out away from the camera's lens to avoid backscatter. Low power settings must also be used because freshwater fish are extremely reflective." **Following page, top**—Steve Philbrook created this photo of a Northern Pike *(Esox lucius)* while teaching his underwater photo class in a lake near Cuyuna, MN. He says: "I was on my way in from teaching an underwater photo class when I came upon this pike. It was one of my first freshwater dives with this camera system, so I wanted to see how far I could push the ISO. As you can see, the noise in the image is quite apparent. I find that ISO 640–800 is the max on cropped-sensor cameras (for underwater shots) before the noise gets out of hand." This image was taken with a Canon T1i in a Watershot housing and a Canon 15mm fisheye lens with only ambient light. The exposure settings were f/7.1, $^{1}/_{200}$ second, and ISO 3200. The best way I have found to offset low ambient light (above or below water) and not use a flash or strobe is to boost the ISO. The other options are to use a wide aperture and/or a slow shutter speed. All three methods have tradeoffs: as Steve mentioned, a high ISO can cause noise; a large aperture results in reduced in depth of field; and a slow shutter speed risks a blurred image, due to your movement or your subject's movement—especially if your shutter speed is under the focal length number of your lens. **Following page, bottom**—Steve Philbrook's helicopter photo is probably my favorite freshwater photograph, ever! It inspired me to do a section on underwater photography in freshwater environments. I featured the shot near the end of this section because it incorporates many aspects of successful freshwater photography: a wide-angle lens (here, the 10mm end of the Tokina 10–17mm fisheye); close proximity to the subject (to reduce the amount of water and its turbidity in the photo); the idea that you can use just ambient light; a higher-than-normal ISO is often employed; and/or a filter can be used. The exposure was f/8, $^{1}/_{100}$ second, and ISO 400. Steve used a Magic Filter (optimized for green water) to create this image.

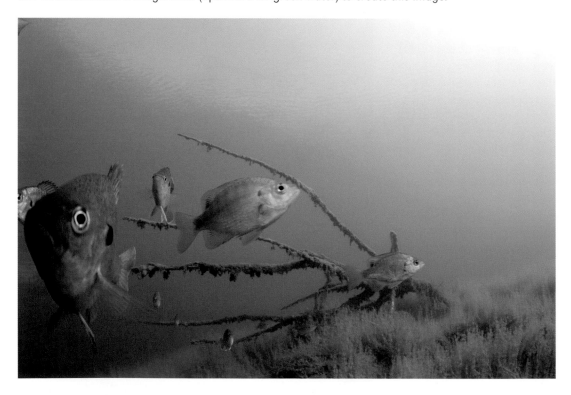

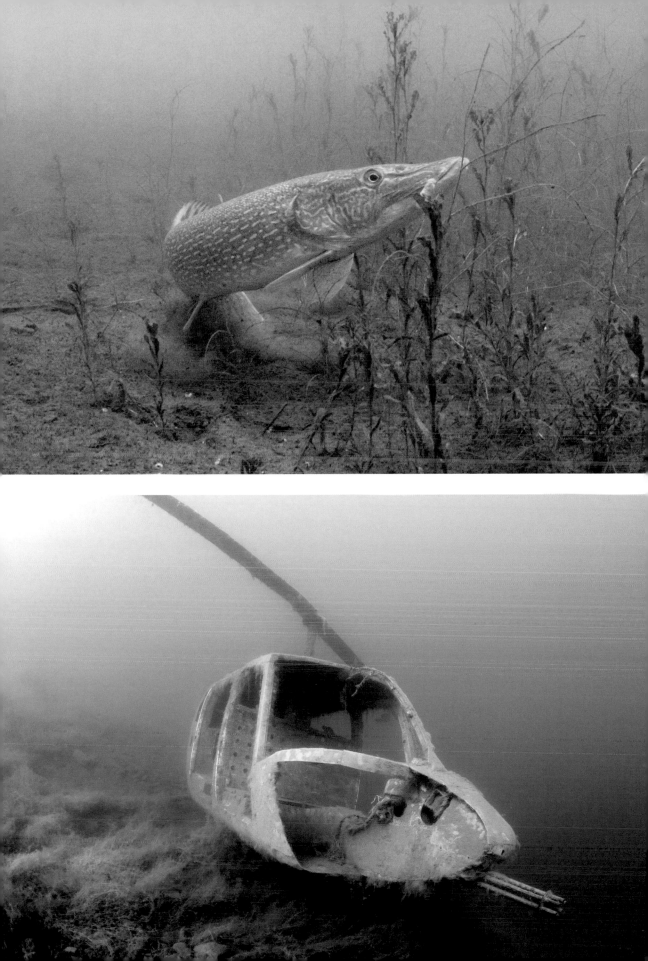

SMARTPHONE PHOTOGRAPHY

Not a lot has changed in the equipment we use in our underwater photography since I wrote my first two books, save advancements in camera technologies and design improvements in some of the equipment we surround our cameras with. One thing is certain, though: more people than ever before are equipped to take underwater photos. In 1993, when I was working as a Divemaster on a boat of twenty to thirty divers, there were just a couple of divers with underwater cameras—and almost all were professionals or boat crew working the dives. Within a few short years, a half a dozen or so of our diving customers were engaged in underwater photography. From 2000 to 2010, the majority of divers on our boats had some form of image-making equipment—either a still photo system or underwater video camera (think GoPro). Within the last five or six years, I have noticed that almost every diver on the boat has some sort of camera system. While I am not ready to declare a paradigm shift in underwater photography, it's worth noting that many divers are using the camera feature on a mobile phone, encased in a custom-made underwater housing, to capture their underwater photographs.

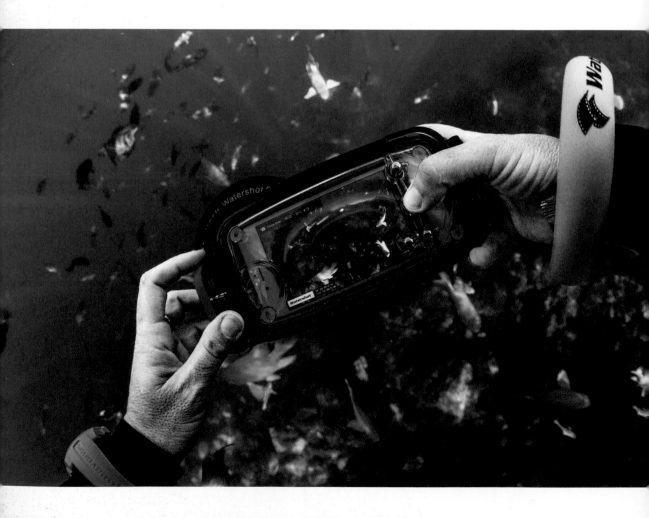

Previous page—Watershot Inc. is the front runner in the development and design of mobile phone underwater photography. Unfortunately, I upgraded my phone a few months before the Watershot Inc. housings came to market, so I have not had an opportunity to buy and use one. Photo courtesy of Watershot Inc. **Top**—Housings and accessories are available for the later model Samsung Galaxy and the iPhone 5s and 6s. Tim Calver captured this photo of a school of Damselfish in San Carlos, Mexico, using his iPhone 6 in a Watershot housing, with the company's wide-angle dome wet-lens accessory. **Bottom**—Using a smartphone camera in a housing (providing a housing is made for your cell phone) is tied in first place in affordability with housing a digital PnS camera (if you already own the camera). The cost of the housings and some accessories are very comparable. In my opinion, using a housed mobile phone is as valid a way of getting started in underwater photography as housing an automatic PnS camera. Tim Calver captured this photo of Spotted Dolphins *(Stenella frontalis)* in Bimini, in the Bahamas. The image clearly illustrates that the smartphone camera, an iPhone 6 in this instance, rivals what we can do with a PnS camera.

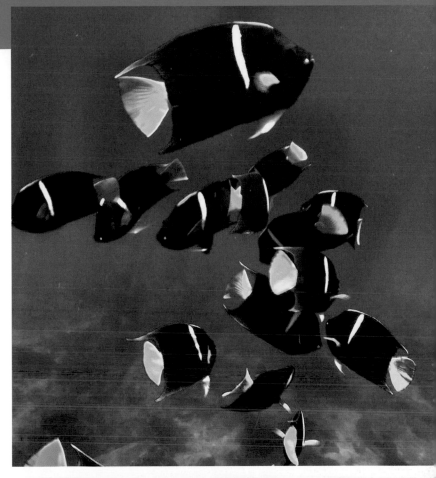

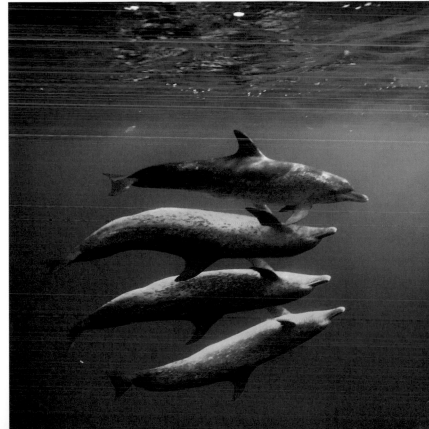

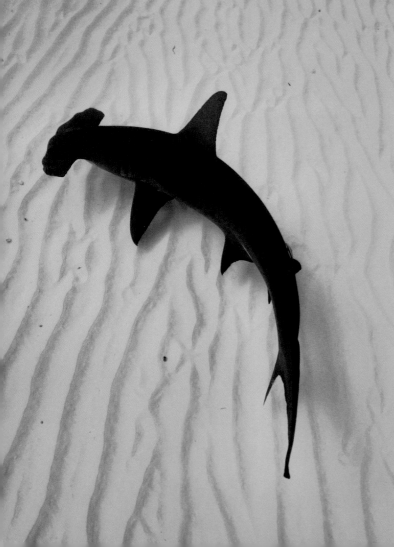

Top—Tim Calver captured a beautiful image of these Spotted Dolphins *(Stenella frontalis)*. His exposure was f/2.2, $\frac{1}{60}$ second, and ISO 40. He used the auto white balance and only available light. It's a good idea to dive with a backup system so that if your main system should fail, you don't miss out on great shots. Bottom—Tim Calver photographed this Scalloped Hammerhead Shark *(Sphyrna lewini)* off-shore in Bimini Island in the Bahamas. A smartphone in a housing is quite capable, and there are color-correction filters available that fit over the housing's port. The housing also has a tripod fitting on its underside, and it won't surprise me to one day see someone using this fitting to mount a camera tray, strobe arm, and strobe and using a fiber-optic cable adapt a strobe to this system. Following page, top—This Green Sea Turtle *(Chelonia mydas)* photo, courtesy of Watershot Inc., was taken with an iPhone 6 in Watershot housing with a wide-angle optical-quality accessory lens/dome port. The 35mm film equivalent focal length is 30mm. The exposure was f/2.2, $\frac{1}{366}$ second, and ISO 32. No flash was used. The image was shot using the auto white balance, in program mode, with matrix metering. Following page, bottom—Tim Calver's photo of an Atlantic Triple Tail *(Lobotes surinamensis)* shows the robust colors that can be captured with smartphone cameras. Here are some of the iPhone 6 camera's specs: 8MP, autofocusing five-element lens, and a maximum aperture of f/2.2. The Samsung Galaxy S6 offers a 16MP CMOS sensor and a maximum aperture of f/1.9. The Watershot housing is depth rated for 195 feet (60 meters). Housings are available from other makers, too. Check the depth ratings when selecting a housing for your phone. Some are rated for 10 feet, others for 30 feet.

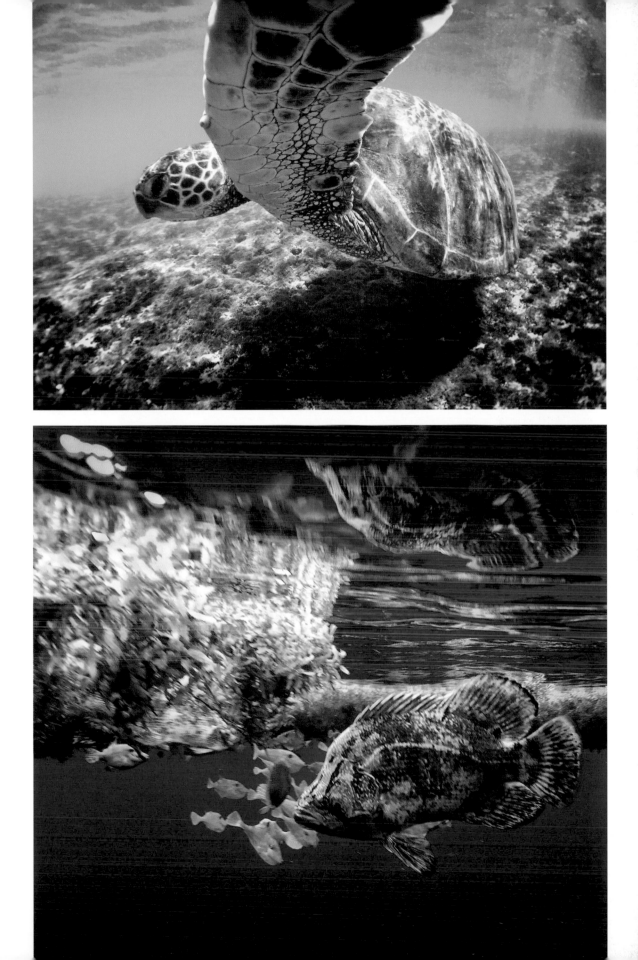

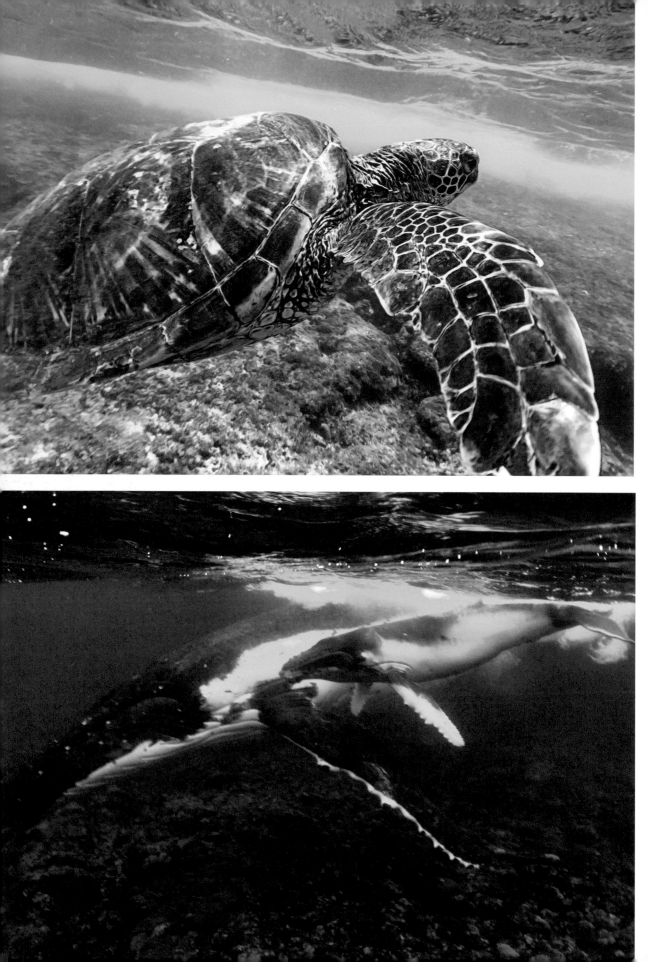

Previous page, top—This image, courtesy of Steve Ogles and Watershot Inc., shows a Green Sea Turtle *(Chelonia mydas)*. The image was captured in shallow Hawaiian waters (where color absorbtion is a nonissue) with an iPhone 6 in Watershot housing. The exposure was f/2.2, $1/366$ second, and ISO 32. No flash was used. ISO 32 is the lowest ISO I have seen to date. **Previous page, bottom**—This mother/calf image of Humpback Whales *(Megaptera novaeangliae)*, courtesy of Tim Calver, was taken using an iPhone 6 in a Watershot housing and the wide-angle accessory. I'm told that there is a macro accessory in development. No EXIF data could be culled from this image file. In any event, the camera made the exposure settings automatically. **Top**—Tim Calver used an iPhone in Watershot housing to capture this fast-moving Harbor Seal *(Phoca vitulina)*. Tim converted the image to grayscale in Adobe Lightroom. **Bottom**—This photo, courtesy of Watershot Inc., shows a smartphone camera, in its housing, with a wide-angle dome adapter mounted. The diver is photographing a school of Garibaldi Fish *(Hypsypops rubicundus)*. Though this system is rated to 195 feet, sans flash or strobe, it works best when used in shallow waters or with a color-correction filter. I'm impressed with the system. It is capable of photographing fish, divers, sharks, dolphins, turtles, and Humpback Whales. That's doing a lot with very little.

POPULAR "HOW TO" IMAGES

Sooner or later, most of us hit a plateau in our underwater photography. We've exploited the full potential of our camera systems. We've taken all the shots we can, or care to, of our favorite subjects. We begin to wonder "Is that all there is?" or we look to move to another level, rather than just doing and shooting the same old stuff over and over again.

Reaching a plateau is not a bad thing. It means we've become more accomplished and moved forward in our underwater photography. We've learned to take an underwater photo—a *good* one.

In this section we will explore some popular types of underwater images made by a photographer who is thinking outside the box.

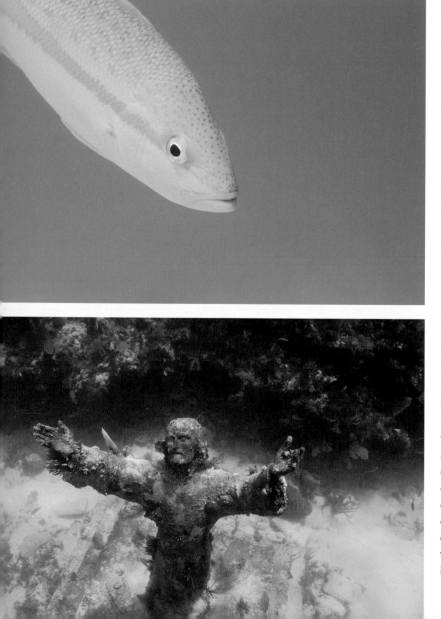

Top—A Yellowtail Snapper *(Ocyurus chrysurus)* is a common subject. This one was photographed with a macro lens and exposed at f/5.7, $^1/_{125}$ second, and ISO 200. No strobe was used. I angled my camera so the fish appears diagonally in the frame to produce a dynamic composition. Bottom—This image of the statue *Christ of the Abyss* is an example of reaching a plateau. I shot with my housed dSLR and 18–55mm lens at 18mm, behind my large dome port. I used one strobe. My exposure was f/8 (for a wider depth of field), $^1/_{125}$ second, and ISO 100 at a distance of $1^1/_2$ feet. But how many images of this subject, taken in this way, do I need in my portfolio? Some readers may answer "none." However, I was thinking a bit out of the box in shooting down at my subject, when the convention is not to do that. When shooting, I consider whether I can photograph my subject in a different way—perhaps from a different vantage point. I look to and what other photographers are doing to give me some ideas that will help me take my imaging to a new level.

Top left—This photo of the statue is a silhouette. I made this image by shooting up from an extreme angle. To create a silhouette, the sun must be out. You use a small aperture of f/16 or f/22 to ensure a dark subject. Because I wanted my subject to be as dark as possible, I did not use a strobe. My exposure was f/22, $^1/_{125}$ second, and ISO 100. The $^1/_{125}$ shutter speed rendered the water column a nice color. With a shutter speed of $^1/_{125}$ or faster, you can capture the sun's rays in the water column, if they are visible to the naked eye. Top right—A digital camera may not offer the dynamic range needed to capture detail in extremely bright areas, like the sun in this photo. If your camera can't capture detail in bright areas, exclude the area from the composition. The exposure for this image was f/22, $^1/_{125}$ second, and ISO 100. No strobe was used. Bottom left—In this attempt, I made two critical errors: I did not exclude the sun from my composition and I used an aperture of f/5.6. The other image elements were spot on: the sun was out, I shot from an extreme angle, and I chose a shutter speed of $^1/_{125}$ second to capture the sun's rays. I shot at ISO 100. Bottom right—Make it a habit to take more than one photo. Try a couple of vantage points, vary your exposure settings, or adjust your relative position to the sun's light. At the end of the day, you will have a selection of compositions to choose from. The exposure for this image was f/22, $^1/_{100}$ second, and ISO 100. No strobe was used.

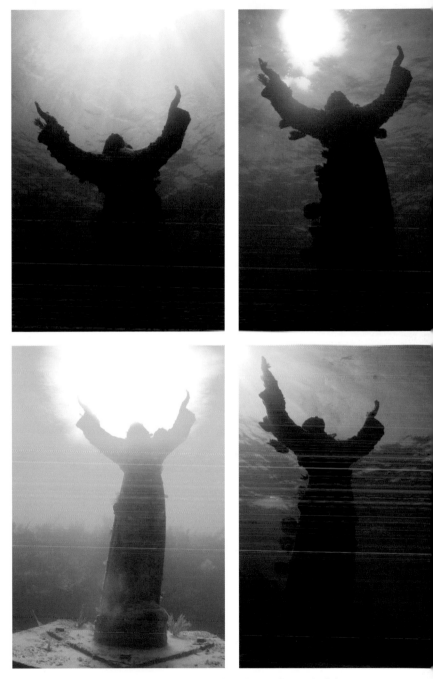

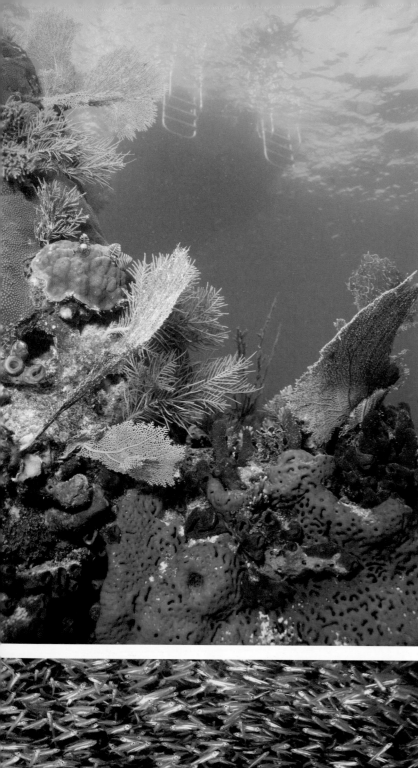

Top—A popular trend in underwater photography, for decades, has been to incorporate two or more subjects in the composition. This type of photo, named by the famous photographer Jim Church (RIP), is called a "close-focus wide-angle" image. (Renowned underwater photographer Howard Hall calls it a "near/far" shot.) Here, I captured a reef scene with corals as the primary subject and the dive boat as a secondary subject. I used close focus and shot very near to the corals. As such, I captured great detail in the corals, such as the Christmas Tree Worms in the center left of the frame. To capture the "far" subject, the boat and ladders, I used the wide end of my lens, 18mm, in portrait format, and shot upward, from below the subjects. I used a single diffused strobe at full power. The exposure was f/5.6, $^1/_{125}$ second, and ISO 100. I was within 2 feet of my primary subject. I exposed for the close subject and let the exposure of the far subject be what it was going to be.

Bottom—This abstract image shows a school of forage fish, possibly Fusiliers. They can be densely packed and found in the 1000s schooling. My idea was to get close enough so the fish filled the frame from corner to corner. I shot with my housed dSLR and a single strobe on top of my camera, set to TTL. These are shiny, reflective subjects and I did not want to wash out the highlights by using full strobe power. I centered the strobe to keep the light even from side to side. My exposure was f/4, $^1/_{125}$ second, and ISO 100. I shot with my lens at 18mm behind my flat port. I was just over 1 foot away from the fish.

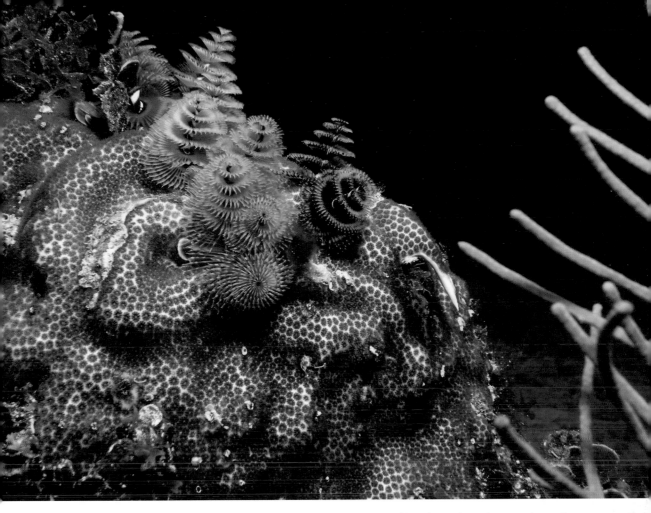

I had two goals in making this photograph of Christmas Tree Worms *(Spirobranchus giganteus)* growing out of the Blushing Star Coral *(Stephanocoenia intersepta)*. One was to make a nice composition of my subject, the Christmas Tree Worms; the second was to create an image with a black background. Images with black backgrounds have gained in popularity in recent years. Creating a black background is easiest when there is nothing but water behind the subject. To produce the effect, choose a vantage point straight across from the subject and use a very fast shutter speed. (I use the fastest shutter speed that will sync with my flash; for this camera, it was $^1/_{500}$ second. I can and do use $^1/_{500}$ second with my DSLR). I use an aperture setting of f/8 or f/11 if my camera/lens permits it. Finally, I set my camera to ISO 50 or ISO 100. For this image, I used the camera's macro setting (which allows for a reduced minimum focus distance). I used the TTL strobe in TTL mode, though I am sure it discharged at full power, given the small aperture and fast shutter speed. I shot with my full-featured Olympus SP 350. The lens was set to the widest angle of view. In other words, I did not zoom in. The exposure was f/8, $^1/_{500}$ second, and ISO 100. My distance from my subject was less than 1 foot.

Below—Susanne Skyrm captured this Grouper portrait in 2014 while on a dive at Little Cayman Island. She shot with a Canon T1i in Watershot housing, with a 60mm macro lens behind a flat port. Susanne also used an Inon S-2000 strobe. The exposure for the image was f/8, $^1/_{180}$ second, and ISO 100. The photo was taken from a distance of $2^1/_2$ feet. Susanne writes: "This grouper was perched on top of a coral formation, waiting to be cleaned. It didn't seem at all nervous to have divers around and allowed me to take numerous shots." The creation of a black background adds an artistic flair to the image and separates the subject from its surroundings. It is easy to see why this type of image is popular. **Following page, top**—Susanne Skyrm captured this image of a Porcupinefish *(Diodontidae)* by the Blue Heron Bridge near West Palm Beach, FL. This shallow water dive locale's bottom is home to many macro-sized subjects as well as other marine life. Dr. Skyrm took this photograph using her Canon T1i in Watershot housing with a 60mm macro lens behind a flat port. She used a single Inon S-2000 strobe. Her exposure settings were consistent with the recipe for making images with black backgrounds: f/11, $^1/_{200}$ second, and ISO 100. Fast shutter speeds darken the surrounding water column and background. Using a small aperture such as f/11 also aids in making the background dark. With these light-restricting exposure settings, the strobe must be discharged at full power. **Following page, bottom**—The word "bokeh" is used to describe the soft, aesthetically pleasing blur of image elements, usually in the background. It is normally purposefully achieved by using as large an aperture opening as possible. Macro lenses can yield nice bokeh. However, in this case, I used a small aperture but still achieved bokeh. This is because there were few things in the background and they were beyond the depth of field of the lens at any aperture I would have used. The subject of this photo is a Slender Filefish *(Monacanthus tuckeri)*, hovering above a Stalk Fire Coral. The fish is the length of your little fingernail. I shot using my housed dSLR and 60mm macro lens behind my flat port. I used one diffused strobe, set to TTL. My exposure settings were f/8, $^1/_{125}$ second, and ISO 100. My glass-to-subject distance was $1^1/_2$ feet.

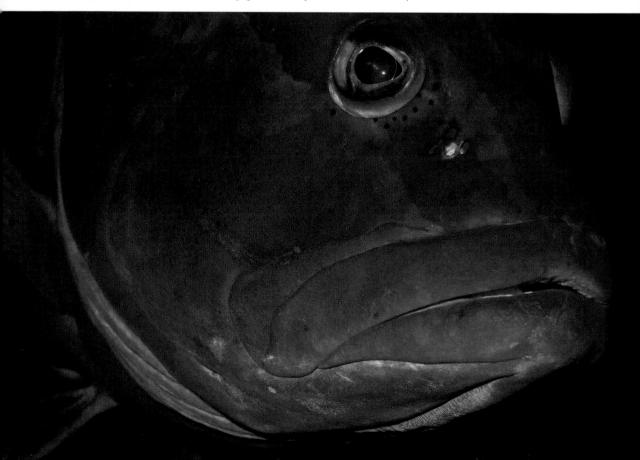

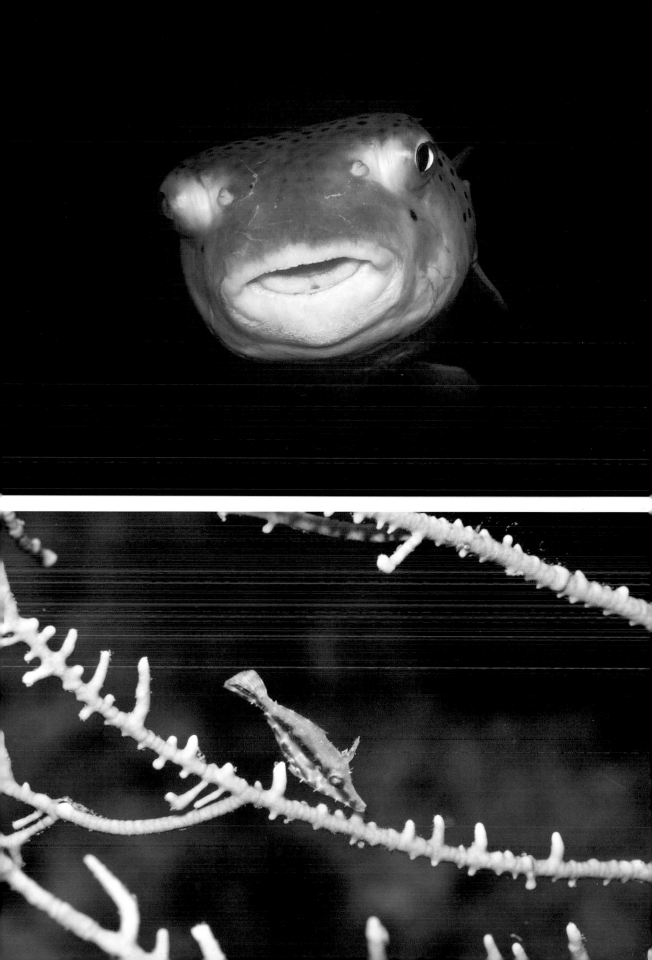

Below—In 2012, I was visiting diving friends who had recently moved to Grand Cayman Island, and we were out diving for fun. I wanted to experiment a little in creating the black background effect. I looked for a subject that was separated from its surroundings—and one I could shoot with only water in the background. I used my housed dSLR and 60mm macro with a flat port, along with a Sea & Sea YS-110a strobe. I set my aperture to f/11, my shutter speed to $^1/_{200}$ second, and my ISO to 100. I set the strobe power to TTL, which is my starting point when shooting with either of my macro lenses. I was 1 foot from this Sea Rod. What barely shows up in the background is a short coral ledge and some sandy bottom on my side of it. The small fish in the scene are Gobies. I could have eliminated the ledge and sand by shooting from a lower vantage point. **Following page, top**—When living in Key Largo, I had a wonderful model to work withwhenever I needed one. Aja Vickers and I met and engaged in making several images together one Sunday morning a few years ago. One type of image I like to create is something I call a "reeflection," a play on the word "reflection." The position of your subject and your vantage point are the key for making a shot like this. Your subject should be close to the surface of the water; slightly under the water will work too, although in my experience, no the subject should be no deeper than 2 feet. My vantage point was below Aja, and I shot up at her from an angle of roughly 45 degrees. I shot

on a bright sunny Sunday. In this shallow water, no strobe was needed. The exposure was f/13, $^1/_{200}$ second, and ISO 100. I used my midrange zoom at 18mm. I was an arm's length away and cropped to a head-and-shoulders presentation in postproduction. **Following page, bottom**—This is an example of an "over/under" or "split" image. As you can see, the subject is both under and above (over) the water. Obviously, these shots are made at the surface or near the surface of the water. Strobe, if used, is usually used under the water and only to provide fill light. A pool with a model is a good place to develop your skills in doing over/unders or splits. This photo was taken using a housed cropped-sensor dSLR with a wide-angle lens set to 18mm behind my large dome port. The exposure was f/11, $^1/_{125}$ second, and ISO 100. No strobe was used.

Top—In this open-water split image, there is a difference in distance between the two subjects in the frame. I made the choice to focus on the near subject, the diver in the water. It is a good idea to do splits using a large dome port, as it is easier to position large dome halfway in and halfway out of the water than it is to position a small dome this way. Bottom—In this split image, courtesy of Steve Ogles of Watershot Inc., we see that it is not mandatory that half the scene be above and half below the water. Flat, calm water is almost a necessity to get the perfect over/under shot, and it is a fun part of the challenge. This image was made using a housed, full-frame Canon dSLR, a 15mm wide angle lens, and a dome port. Even without strobes mounted, a full-frame camera system is heavy and cumbersome to hoist out of the water in water that is too deep to stand up in. This makes grabbing a split shot even tougher. The exposure for this image was f/9, $^1/_{800}$ second, and ISO 640. No strobe was used.

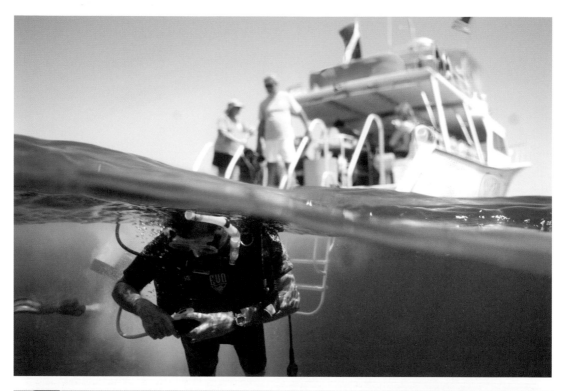

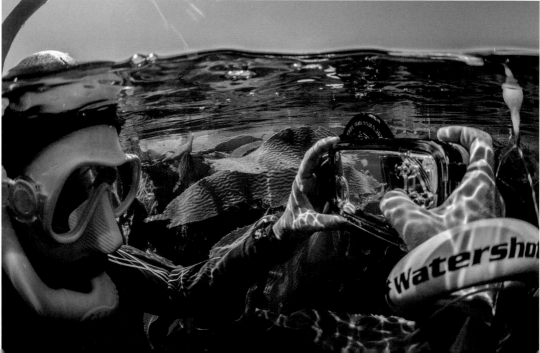

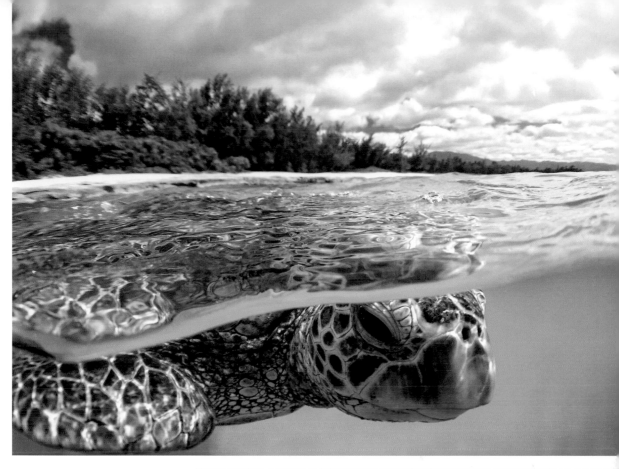

Top—Splits are easier to create in shallow water near shore as seen in this image, courtesy of Steve Ogles of Watershot Inc. This photo was taken using a Watershot-housed iPhone 6 with a wide angle dome port (about 3 inches in diameter) fixed to it. The turtle was cooperative. The iPhone camera's auto settings were f/2.2, $^1/_{1500}$ second, and ISO 32. The focal length was 4mm. Bottom—Here, I took "Snell's Window" a step further—I photographed what was *in* Snell's Window. "Snell's Window" is the surface of the water visible in underwater

photos when we shoot upward. You can kind of see Snell's Window in my close-focus-wide angle image shown earlier. Often, there is nothing in Snell's Window to shoot. In this case, we see a diving board. I've seen similar photos taken that show, through the window, a dive boat's side with its name written on it. I've also seen a photo that showed, in the window, the back of the dive boat and its crew standing there. To create this image, I used my cropped-sensor Canon dSLR and the 18mm end of my 18–55mm lens, which was behind my small dome port. I did not use a strobe. The exposure was f/13, $^1/_{125}$ second, and ISO 100. Calm, clear water aids immensely in creating these shots.

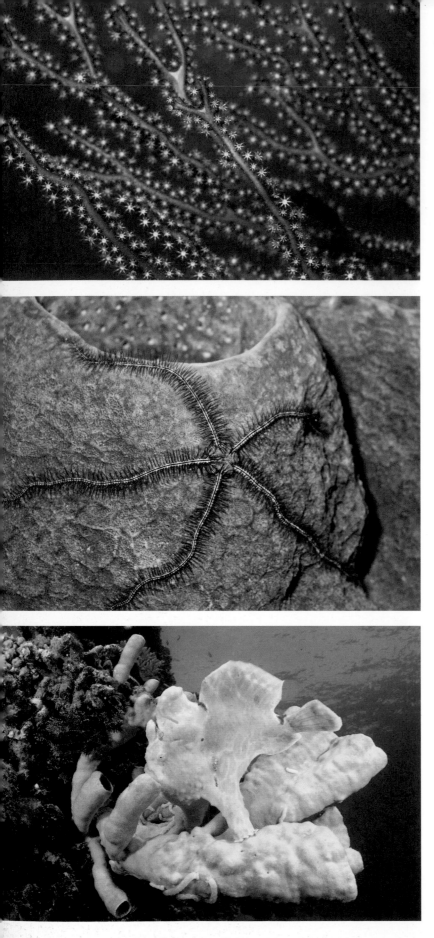

Top—Susanne Skyrm used her good eye and imagination to create an artful view of this Gorgonian Coral while diving in the waters of St. Croix, US Virgin Islands. She used her Canon T1i in Watershot housing and mounted her 60mm macro lens behind a flat port. Her Inon S-2000 strobe was set at TTL. The exposure was f/8, $1/180$ second, and ISO 100. The delicate structure and colors of this Gorgonian make a lovely abstract image. **Center**—This image of a Brittle Star *(Ophiothrix spp.)*, courtesy of Susanne Skyrm, was photographed in the current-laden waters of Cozumel, Mexico. Here, Susanne captured a specimen shot of an aquatic organism in an artful way. Susanne used her housed Canon dSLR, a 60mm macro lens behind a flat port, and a strobe centered over the top of her system. She was 2 feet from the subject and exposed at f/9.5, $1/125$ second, and ISO 100. **Bottom**—Steve Philbrook used a Tokina 10–17mm fisheye lens at 16mm to capture this "close-focus/wide-angle-macro" image. Creating an image like this requires an ultra-wide-angle lens and a very close focusing distance. The "macro" part is that the subject is normally quite small (as is this 4-inch Frogfish or Anglerfish *[Antennariide]*) and best photographed with a macro lens or macro setting. Steve writes: "I like to use mini domes for these images because it allows me to get very close to my subject, which in turn creates a very interesting perspective." Steve used his Canon 7D dSLR and mounted his lens behind a 4.33-inch mini dome port. His manual exposure was f/10, $1/200$ second, and ISO 320. He used a pair of Inon Z-240 strobes in TTL mode.

Top—When we are at a plateau and making the same images, such as this purple or common Sea Fan *(Gorgonia ventalina)* and sponge reef scene, we can try to think of a new approach. This shot was taken in the portrait format and from less than 2 feet away using a Canon T1i dSLR with a variable lens zoomed to 25mm behind a large dome port. The exposure, made with one diffused strobe, was f/8, $^1/_{125}$ second, and ISO 100. This was not a particularly difficult capture, but it's a pleasing reef scene—one we can do all day long, day in and day out. **Bottom**—On the other hand, we can try to come up with new and different ways to photograph the subject. In this case, I removed my strobe from its arm and carefully positioned it to back/side light my subject, the common Sea Fan *(Gorgonia ventalina)*. Its latticework has nice detail, so I opted to create an abstract. I took pains to not damage the coral (this should be a given whenever we engage in underwater photography, regardless of our subjects). My strobe was diffused, and I had to hold it off to the side because of my reach and also because, had I strictly back-lit this image, I would have overexposed everything. I set my variable zoom lens to 55mm and shot from a distance of 1 foot in front of the Sea Fan. My exposure settings were f/16, $^1/_{125}$ second, and ISO 200.

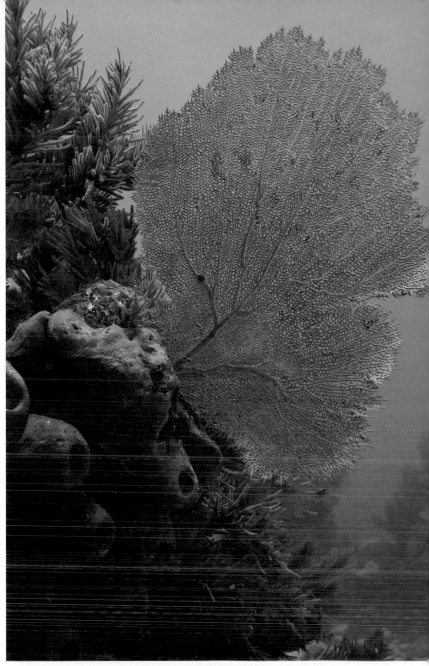

Post-Processing

Well, we've taken our photographs, our trip is over, and we are home. It is time for some more fun. This "fun" has a couple of names. Some people call it "photo editing" (though I think "editing" technically means deleting unacceptable photos). Most of us call this fun "post-capture photo processing," "post-processing," or simply "post" (as in, "I can adjust my photo's exposure in post.").

I try to keep my photo editing to a minimum. There is a saying that "there is no such thing as too much fun," but I shoot a lot, and spending time in postproduction can feel tedious. I try to take the best photograph I can so that I can limit the postproduction time needed to enhance the image using any number of photo-editing programs. Still, having an efficient workflow is critical, and in this chapter I will show you how I organize, view, edit, and in some cases and, when need be, "process" my images.

Download Folder

I have a Download folder on my desktop. I copy, not move, my original image into this folder when I return from a dive. I leave my

Top—I have my camera set to display this screen after I have taken a photograph. It is visible until I touch any other control, like my shutter speed. All cameras will show you what you took a picture of on their LCDs. I like that and I appreciate the additional information it provides—such as my exposure settings and the image's histogram too. I rely on the histogram to see whether I have over- or underexposed my photo as much or more than I look at the thumbnail-sized photo. This information saves me a lot of time in postproduction and helps me determine whether to take another photo of my subject. Bottom—Here's a view of my desktop. I create a working folder for my images here and copy my downloaded photos into it.

Top—The "before" shot contains backscatter. **Bottom**—I used the Healing Brush to click on the spots that I wanted to "heal." Here is the result.

photos on my camera memory card until I am finished with my editing and have my photos backed up. Then I format my camera memory card in-camera. I review my images in a basic photo-viewing application and discard images that are grossly over- or underexposed, have too much backscatter, and are poorly composed or out of focus.

Once I have my keepers, I import them into Adobe Lightroom (now in its Creative Cloud version). This has become my favorite editing program. I started with LR 2, then 3 and 3.6, and am currently using LR 5.7. If I have done my job with my camera, the program will do the "post" job—and then some.

Key Words

My first step in postproduction is to assign key words to my images. Tagging photos with a key word or multiple key words can help you to find a particular photo at a later date. A drawback to key wording is that not all photo editing/processing programs will recognize key words applied using software from another manufacturer. If you are trying to find an image, you may need to bring your folder(s) into the program you used to key word your files.

Reviewing the Images

My next step is to examine my photos for backscatter. Backscatter appears when

particulate matter in the water column between the lens and subject is illuminated by strobe. In Lightroom, I use the Clone tool or Healing Brush to remove the unwanted spots. The editing can also be done in Elements. If all I need to do to an image is clone out backscatter, it is easier to open the image in Elements, Clone, and save, than to import the image into Lightroom and do it there.

Checking the Histogram

My next step is to review the histogram to check the exposure of the photograph. This step is critical because, if an image is grossly under- or overexposed, it makes no sense to do any color adjustments or enhancing.

If the histogram data reaches the far left or far right side, the darkest and lightest tones in the image will lack detail.

Lightroom Advantages

In the past, I used Adobe Photoshop (and later Elements) to make my corrections to both exposure and color using the Levels feature. I'd make my adjustments one color channel (R, G, B) at a time and watch for changes in the image and histogram. One

advantage to editing in Lightroom is that all of the tools are "open" and shown in the right-hand panel. I don't necessarily use each tool, but I do start from the top of the list and work my way down.

Exporting Images

Once I have removed backscatter and made any necessary color or exposure adjustments, I export my photos to my utility folder: LR Export. From there I move them into the folder I created for the shoot. Finally, I create a subfolder in the shoot folder named "originals" and open it. I grab all the photos from my LR Import folder (yes they are still there and in their original, unaltered state) and move them to this subfolder. I back up the shoot folder onto two external hard drives, then format my memory card in-camera.

Finding Files

I sometimes have trouble locating an image file that I know I have *somewhere*. Though I may have key-worded an image, named it with a memorable name, and put it in a folder where logic would tell me I would find it, I can't seem to locate it.

A histogram is a visual depiction of the range of tones in your image, from pure black to pure white.

Vivid-Pix is an easy-to-use image adjustment program designed by a team of software desginers, photographers, and divers. The auto corrections are impressive!

Years ago, I stumbled across a free "photo finder" application named Picasa. It scans my hard drive, locates the folders I have images in, then shows those folders in its left pane. Thumbnails of the images in a selected folder are displayed in the right pane. Picasa has saved me a lot of time when my memory forsakes me. It also has an email feature that allows you to send/ receive non-destructively downsized images.

Size and Watermarking

I share photos on the Internet via my blog and Facebook. I don't mind sharing my photos with my friends, but if they are re-shared, I'd like anyone who views them to know who took and owns the photo. I use Picasa for re-sizing and Elements for watermarking, but it can be done in Lightroom too. These resized and watermaked images are stored in my Size and Watermarking folder.

Copyright Folder

My final working folder is my Copyright Holding Folder. While we all automatically own the copyright to our photos, I get mine registered with the US Copyright Office. It costs the same whether I submit one image or a thousand. I use this folder to hold copies of photos until I've got a large enough number of image to burn to CDs and send to the Copyright Registration office, along with a check for the fee.

Vivid-Pix

During my compilation of this work, I came across a new-to-market photo editing program named Vivid-Pix. Its creators Rick Voight and his partner Randy Fredlund are software engineers, photographers, and divers. They created and patented a very simple to use, virtually automatic photo-editing program designed to auto-correct underwater photos.

Vivid-Pix is available as a free 30 day trial download; when the trial period ends, the program can be purchased for $50.

I can't compare the program to anything, but I feel that it does a better job of the "autos" (levels, color, lighting, etc.) found in other editing programs I have used.

Conclusion

This short workflow covers most my bases. You can use it to get started in organizing, editing, enhancing, storing, finding, and using your own images. I think one of the rules in using Lightroom is "have fun." I like that!

Contributors

Steve Philbrook

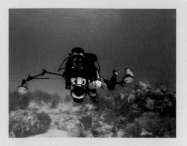

Steve Philbrook (pictured at left) and his wife Jolene are professional underwater photographers and the owners of Aquaventure Dive and Photo Center in Maple Grove, MN (http://aquaventurescuba.com). Steve contributed images and comments about images he made in varied shooting environments—including freshwater. I appreciate Steve's support in this work because I stopped taking photos in freshwater over 20 years ago and my images were lost over time.

Steve Ogles

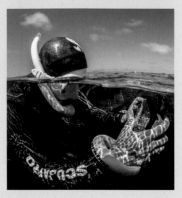

Droves of photographers now encase their smartphones in waterproof and pressure-proof (to 195 feet) polycarbonate housings to take photographs underwater. Watershot Inc., of San Diego, CA, is the largest developer, designer, and front runner in bringing this type of underwater photography to the market. Steve Ogles, president and CEO of Watershot Inc. (www.watershot.com), started making housings in 10th grade to take videos of his surfer friends. His company made the housings used to film on and underwater during the making of the *Pirates of the Caribbean* movies. Later, Watershot Inc., brought to market the housing system that I use in my own underwater photography. I express deep gratitude to Watershot and to Steve for providing some of the imagery taken using his housing and accessories used in this work.

Tim Calver

Watershot engaged Tim Calver (www.timcalver.com) as a consultant during the development of their dSLR and smartphone housing systems. Tim is a freelance professional topside and underwater photographer with a distinguished list of clients and a deep portfolio. Knowing this, I engaged him to provide images he made using the Watershot/iPhone camera system. Tim's images illustrate the potential of this system, and I thank him wholeheartedly for lending his expertise and images.

Hector Seguin, Jr.

Semi-professional underwater photographer and videographer, Hector Seguin, Jr. is the owner/operator of Honolulu Honu Divers, LLC of Honolulu, HI (http://honoluluhonudivers.com). He also runs a small boat, intimate-dive charter service. He is my "Eel Whisperer" and go-to guy in Oahu. Hector uses the Sea Life DC 1000 camera and housing for still photography and the GoPro system for his video imagery as part of his service to his customers. I thank Hector for helping me build a case for the often-underrated PnS camera.

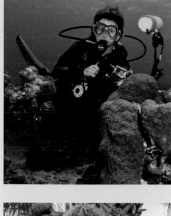

Denise Owen

Denise Owen was a SCUBA Instructor and underwater photographer in the Bahamas who hailed from the United Kingdom. She is now an attorney in Grand Cayman Island. She came to me many years ago, looking for some guidance after acquiring a housed dSLR camera system. Denise uses a housed full-frame dSLR and has a sharp eye for macro photography. Thank you, Denise, for permitting me to use my photos taken of you to help illustrate this work and for the use of your image, as I wanted to include an image taken with a full-frame dSLR in this work.

Susanne Skyrm

Susanne Skyrm, PhD, also contributed to this work. Dr. Skyrm is a tenured professor of music at the University of South Dakota, a PADI Divemaster, and a more-than-avid underwater and serious topside photographer. Susanne is my dive-photo buddy, and we have engaged in this together over many years. Dr. Skyrm provides this work with freshwater imagery; a sprinkling of her saltwater imagery is also featured. Susanne uses a Canon dSLR and Watershot housing. She uses two strobes when needed and has the full repertoire of lenses and ports mentioned in this work. Thank you, Susanne. Photo courtesy of M. Burk Walker.

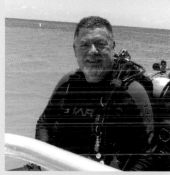

John Shaheen

Thank you to John Shaheen for lending photos that show the types of images that can be made with the current crop of full-featured PnS camera systems. John is an accomplished photographer who has began taking photographs since he was ten years old. He has been engaged in underwater photography for eight years and is well-traveled a key to underwater photography. John and I met several years ago during a trip to Key Largo and immediately became friends. John uses an Olympus XZ-1 Camera, Nauticam housing, Inon UWL-H100 28M67 wide-angle conversion lens (wet) with an Inon Dome Unit II. He also uses two Sea & Sea strobes, a YS-01 and a YS-D1. Contributor photo courtesy of Scott Edick.

Matthew Landau

I also extend a thank you to Professor Matthew Landau, PhD, of the marine sciences department at Stockton University, NJ. Professor Matt is a longtime friend—and he proved it by helping me with the taxonomical naming of the aquatic life in this work. I take full responsibility for any errors in this aspect of the work. Thank you, Professor Matt, for a huge effort at the last minute!

Index

Storytelling for Photojournalists

Enzo dal Verme (*Vanity Fair, l'Uomo Vogue*, and more) shows you how to create compelling narratives with images. *$37.95 list, 7x10, 128p, 200 color images, index, order no. 2084.*

Senior Style

Tim Schooler is well-known for his fashion-forward senior portraits. In this book, he walks you through his approach to lighting, posing, and more. *$37.95 list, 7.5x10, 128p, 220 color images, index, order no. 2089.*

After the Camera

Thom Rouse creates artwork that begins with nude and portrait photos, then spirals out into other worlds through creative postproduction compositing. *$29.95 list, 7x10, 128p, 220 color images, index, order no. 2085.*

The Complete Guide to Bird Photography

Jeffrey Rich shows you how to choose gear, get close, and capture the perfect moment. A must for bird lovers! *$29.95 list, 7x10, 128p, 294 color images, index, order no. 2090.*

Shot in the Dark

Brett Florens tackles low light photography, showing you how to create amazing portrait and wedding images in challenging conditions. *$29.95 list, 7x10, 128p, 180 color images, index, order no. 2086.*

Relationship Portraits

Tim Walden shows you how he infuses his black & white portraits with narrative and emotion, for breath-taking results that will stand the test of time. *$34.95 list, 7x10, 128p, 180 color images, index, order no. 2091.*

Cheap Tricks

Chris Grey shares inventive lighting solutions and techniques that yield outstanding, creative portraits—without breaking the bank! *$29.95 list, 7x10, 128p, 206 color images, index, order no. 2087.*

Sikh Weddings

Gurm Sohal is your expert guide to photographing this growing sector of the wedding market. With these skills, you'll shoot with confidence! *$37.95 list, 7x10, 128p, 180 color images, index, order no. 2093.*

Mastering Light

Curley Marshall presents some of his favorite images and explores the classic lighting approaches he used to make them more expressive. *$34.95 list, 7x10, 128p, 180 color images, order no. 2088.*

Profit-Building for Pro Photographers

Jeff and Carolle Dachowski teach you marketing, pricing, sales, and branding—the keys to a successful business. *$37.95 list, 7x10, 128p, 180 color images, index, order no. 2094.*